SITTINGBOURNE
THROUGH TIME
Robert Turcan

AMBERLEY

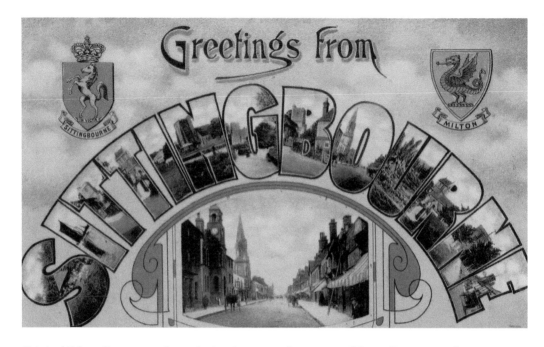

Original Edwardian postcard, employing image used on cover of first edition Sittingbourne Through Time.

To Ophelia and all the granddaughters of Sittingbourne

First published 2009
This edition published 2015

Amberley Publishing Plc
The Hill, Stroud,
Gloucestershire GL5 4EP

www.amberley-books.com

Copyright © Robert Turcan, 2009, 2015

The right of Robert Turcan to be identified as the Author of this work has been asserted in accordance with the Copyrights, Designs and Patents Act 1988.

ISBN 978 1 4456 5021 0 (print)
ISBN 978 1 4456 5022 7 (ebook)

British Library Cataloguing in Publication Data.
A catalogue record for this book is available from the British Library.

Typesetting by Amberley Publishing.
Printed in the UK.

Introduction

Nostalgia continues to be what it always was, a warm appreciation of the past. This sentiment grows with an ageing national population, who fondly collect past artefacts such as topographical postcards and are more likely to be joining local history study groups.

Revising this book after six years allowed different aspects of this town's past to be examined. Many images are fresh, but some places and subjects are revisited. Inevitably, however, with a linear town developing along the main arterial coaching route between the capital and the continent, its High Street deservedly merits greater consideration. Therefore, a more extensive collection of images from this area have been included.

Waterways have been given greater emphasis. After all it was over narrow seas that Roman legions invaded Kent. The prows of their galleons nosed their way gingerly into the muddy creeks of Swale. Local evidence of their colonisation can be found, with villa remains at Hartlip and Newbury near Upper Rodmersham. In fact there are shards of Samian ware pottery scattered all over the whole of this district.

At the head of the main inlet from the coast, Milton or 'Middletune' (meaning middle town between Canterbury and Rochester) was established. William the Conqueror held the manor under his crown rights and it remained a royal possession for centuries. Perhaps, speculatively, at a day's fast ride from London it could have proved a safe embarkation point for fleeing monarchs escaping to the Continent. Certainly, returning from less fictional fantasy, the creek was an excellent commercial port.

Wool in Tudor England was the basis of this country's emerging wealth. The lush marshland pastures northwards became extensive grazing areas, while a less honest prevalent local spinoff from this husbandry was owling. This was a converse method of smuggling contrived to evade export duties.

Town commerce was boosted by pilgrims breaking their journeys here for rest and refreshment. The shrine of Thomas Becket at Canterbury Cathedral was an international religious magnet. Inns and

taverns that opened to cater for this trade prospered. One of the oldest is the Lion, in the central High Street, it is famous for hosting Henry V on his triumphant march back to his London headquarters after the battle of Agincourt exactly 600 years ago.

Later the early Hanoverian kings favoured stopping off here on their commutes between kingdoms here and in Germany. Luxurious coaching inns such as the Rose were renowned for being some of the best in the land. Indeed Queen Victoria was often a patron on her way to holidays in Thanet.

The most dramatic event shaping the town's economic future arrived with a railway track around 1860. Its convenience meant that by this time relative populations between Milton and Sittingbourne were equal at around 5,000 each. Meanwhile heavy industry and extraction of local raw materials such as brick earth and chalk for building materials was underway. These bulk goods, including paper and fruit preserves, were transported to London on Thames sailing barges. These vessels had a shallow draught, ideal for the shoals of the estuary they had to navigate. They required skilled seamanship as they carried heavy loads, often without supplementary engine back-up power. Metropolitan growth owed much to these bargees who delivered the necessary bricks and cement for its construction.

The Euro link industrial trading estate is well established at the geographical centre of Sittingbourne. The expediency of placing it there is understandable as it was a redundant brick field. The transport consequences are far less practical. Finished goods from secondary industrial firms have to depart by road instead of by sea. Unfortunately raw materials arrive in a similar fashion, along with workers vehicles. Another section of the Northern distribution road has been completed since 2009. It has partly assisted traffic congestion, but its final western part has not yet been completed.

As a prelude to declaring record annual losses of some £6 billion, Tesco withdrew its extravagant plans for a mega-store with bridge walkway in the town centre. Instead of further messing with an extraordinarily odd road system which cuts off the railway station from its users, perhaps a solution would be to move it to Stone Farm Bapchild (already zoned for housing) and truly build a civic square or piazza where it was. This could attract businesses offering better shops, leisure facilities and office space as visitors could park freely in the large cleared space and be a few steps from where they wish to transact business. The hopes for a new town centre envisioned six years ago have been dulled. However, organic changes and perceptible improvements can be gleaned from the following pictures and captions.

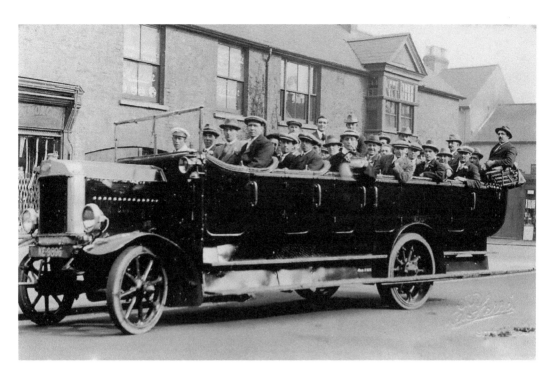

Coaching

Sittingbourne's urban genesis was boosted by its stopover advantage for travellers to Continental Europe and London. The eighteenth century saw palatial hotels established along the high street. Their imposing structures largely remain above shop fronts, but as these illustrations portray this traditional form of transport continues to be popular.

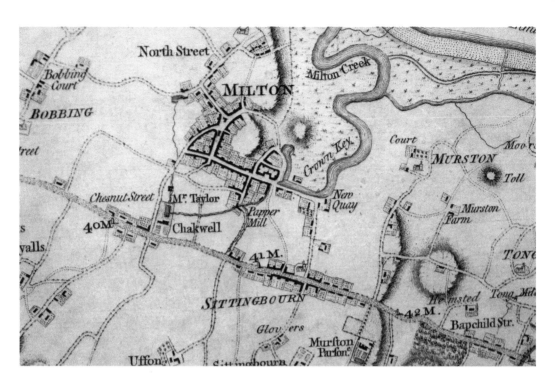

Urban Expansion

John Carey's map of 1769 above depicts buildings contained along a short corridor of Watling Street. Historically, development first emerged between two streams running north from what are now called Bell Road and Ufton Lane. Population growth was then ignited by railway mania and by around 1850 it equalled its much more venerable neighbour Milton at roughly 5,000.

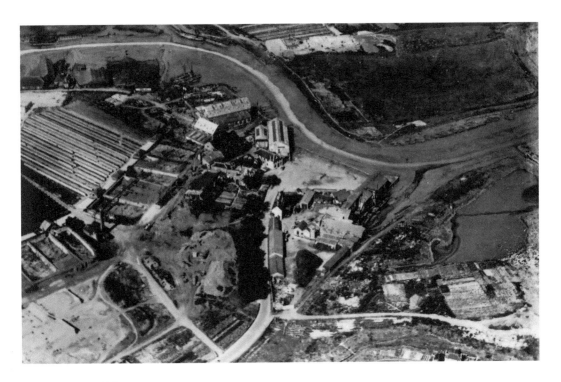

1930s Aerial Survey

The photograph above shows Milton Creek surrounded by wharfs, warehouses and to the extreme left, rows of apparatus for drying freshly moulded bricks. Below, open undeveloped land is still visible southwards. In the top right corner the largest roof is the railway station. This structure has since been removed along with much Victorian terraced housing.

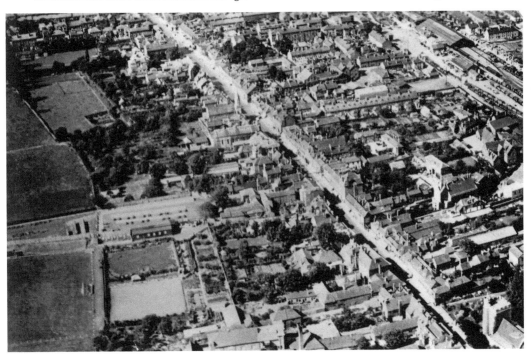

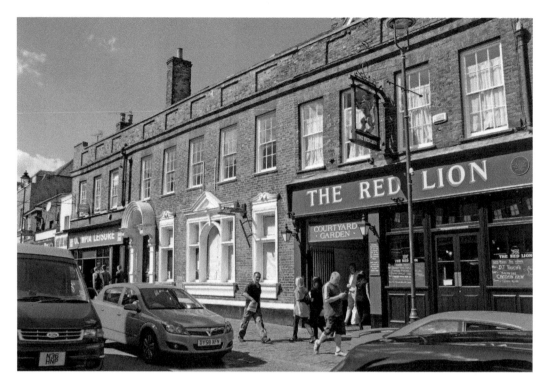

The Red Lion

The Red Lion has a rich historical background. As can be perceived below from the picture of the rear of the pub, it was once a much larger building. Henry V was entertained here on his triumphant return from the battle of Agincourt. On this occasion the bill for wine consumed amounted to some 9s. With wine at an old penny per pint, a bibulous evening was enjoyed by one and all.

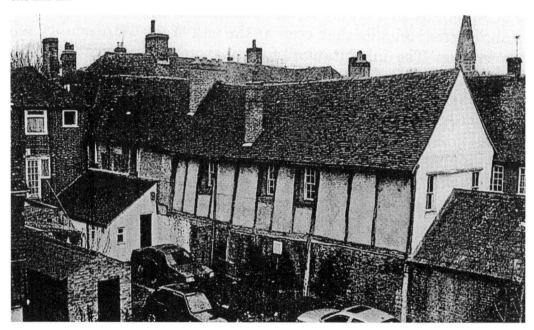

Milton Creek

From at least Roman times, vessels have ventured into Milton Creek. Viking invaders followed and until road and rail haulage became universal it was the main arterial route for goods traffic to Swale. Barges were the last type of ship to be prevalent. They could shift loads of around 100 tonnes with their draft of a similar figure.

Purposeful work amongst smart premises is seen in the archive image. The workmen might be loading sacks of wool or hops. More likely loads would have been bricks and cement. Below a forlorn scene contrasts. A utilitarian portal industrial building has replaced port offices and economic activity has switched to metal bashing.

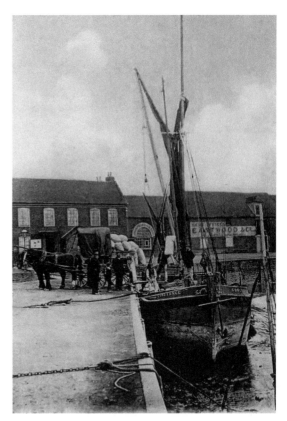

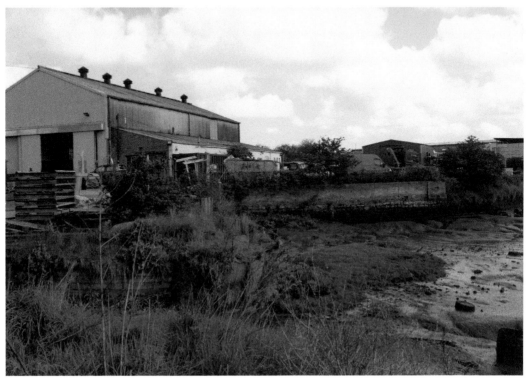

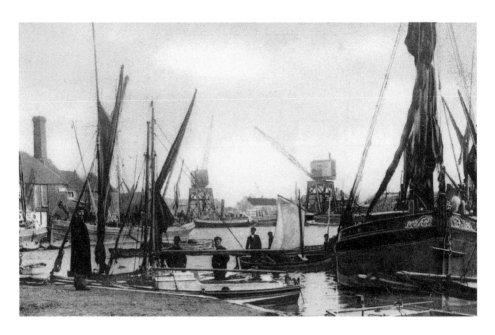

Bargees

Superlative sailing skills were demanded of bargees. Their duties required manoeuvring heavily laden shallow hulled craft in constantly variable tidal waters. The crowded, deserted juxtaposed images here depict this occupation at its height and disappearance. The postcard picture above shows bargemen sailing off on a full tide. The destination was invariably Port of London or other Thames Estuary docks. A few of these mercantile seamen saw their boats converted into leisure or residential use. More likely their demise was slow decay in a forgotten backwater.

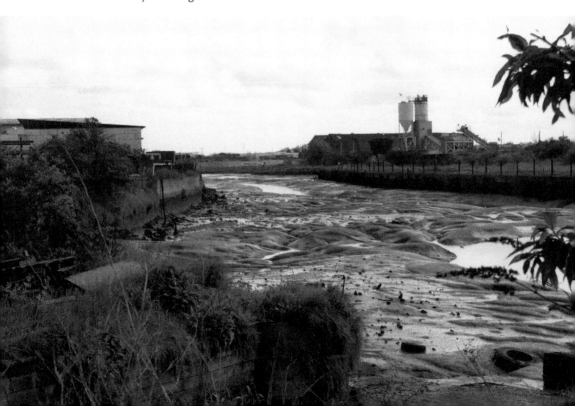

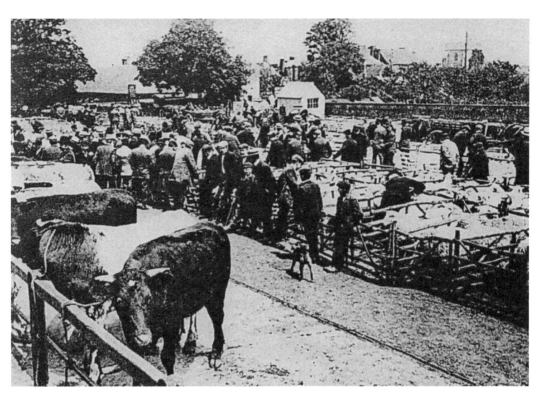

Market Day

Cattle market auctions were a weekly occurrence on land near where Sainsbury's car park now stands. Latterly, Friday general market stalls were erected here before moving to the car park opposite Sittingbourne railway station.

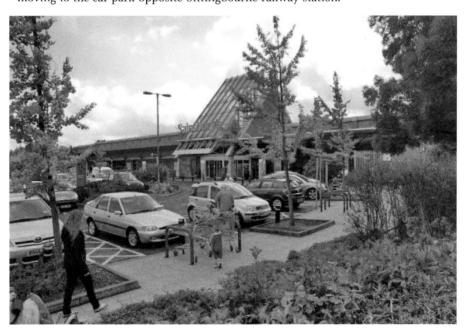

YE OLDE BULL HOTEL . SITTINGBOURNE 1353-1965

Tel. 3446

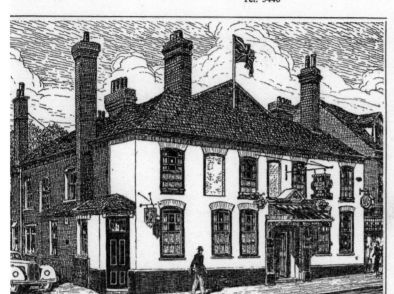

This ancient hostelrie in Sittingbourne, a town founded by the Saxons and set amidst the orchards and hop-gardens of one of the most beautiful parts of Kent, was built over 600 years ago. First licensed by the Monks of Chilham Castle in the 12th century, the property was later bequeathed by the landlord to his wife Annabella in 1368, records of which are registered in Somerset House in London. Today 600 years later you will find good Kentish ales, wines and fare served within these historic walls, and with its twenty-five bedrooms complete with every modern convenience, attractively combines the old with the new amidst surroundings little changed with the passing of the years.

The Bull Inn

The Bull Inn was well placed for custom from farmers and live-stock dealers who regularly attended nearby auctions. There used to be a side entrance with a 'buttery' sign above. Some people in their ignorance believed this indicated something to do with the soft edible stuff. However, the term referred to butts, which contained either wine or beer. In the meadow behind, pens were erected for animal sales. Now this area has been developed into the Swallows Leisure Centre. It includes a swimming pool, replacing the original one demolished at St Michael's Road or, as it was then called, the Butts, this time referring to an old target practice area for archery.

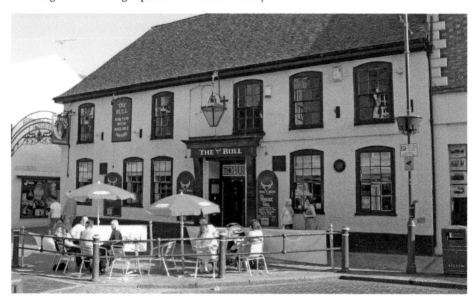

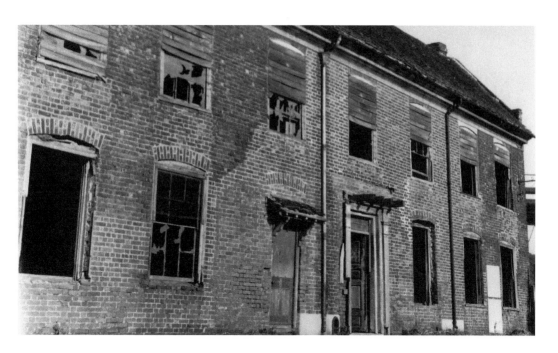

Port Reeve Office and Residence

Before demolition, the harbour master's buildings at the head of the creek, known as the Town Quay, had a ghostly look of past glory. Historically a port reeve would have held administration with heavy responsibilities for levying dues and excise control. Furthermore, he had municipal responsibilities for the town of Milton. Acting as a quasi-mayor, he was elected annually on a saint's day. Sadly, this lovely Georgian façade above was razed to the ground for the local paper maker (Bowater) to replace it with a foundry. This in turn was demolished and replaced by the current portal building of a structural steel firm.

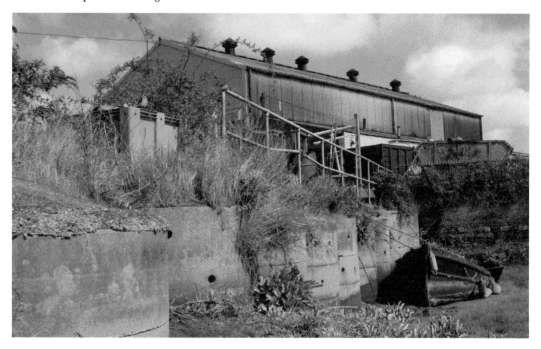

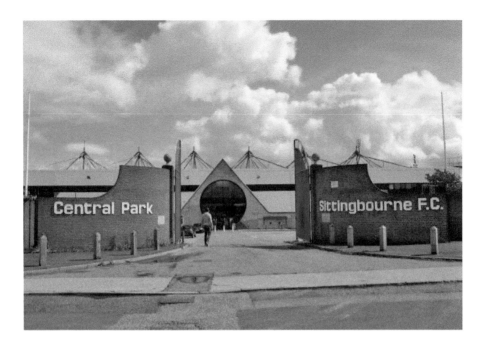

Sittingbourne Football Club

The club moved in the 1990s to its new home at Murston after selling off the Bull Ground for shop redevelopment. The football club found it impossible to finance playing in the new stadium and, after just a few years, moved to a smaller ground within the same complex. Greyhound racing has continued to this day in the main arena. Pictured below is a team shot from 1936, when past and present players competed in a 2-2 drawn game.

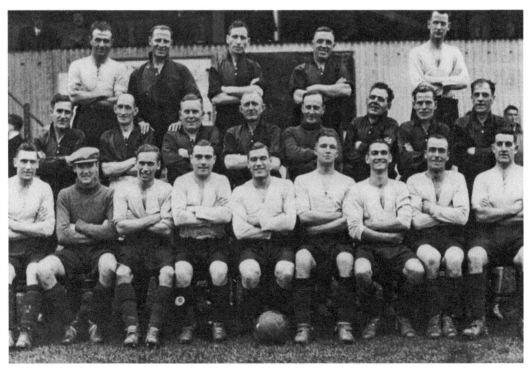

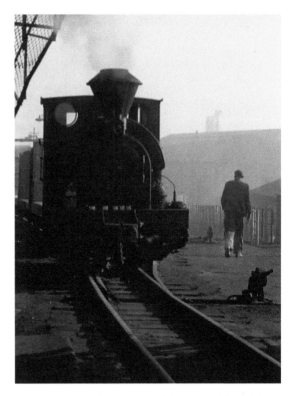

Kemsley Light Railway
The Kemsley Light railway facilitated the bulk movement of seaborne timber from cranes to production plant in Sittingbourne Mill. Its rails were supported by innovative use of reinforced concrete. Now a valued working tourist attraction, its restoration, maintenance and preservation is owed to enthusiasts such as Keith Chisman. Pictured opposite with his cap and stick inspecting the Oliver Cromwell locomotive which passed through the town on May 2011, this venerable gentleman should also be applauded for his past chairmanship of Milton Regis Court Hall Committee.

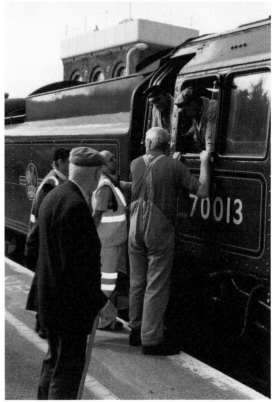

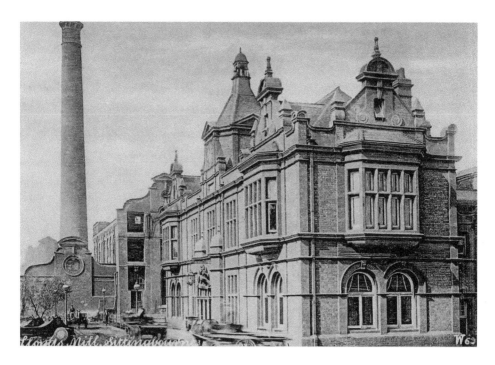

Sittingbourne Paper Mill

Paper manufacture was a principle part of Sittingbourne for over 300 years. The factory above has been owned by Lloyds, Bowaters, Fletcher Challenge and lastly, before closure, M-real. Increased agricultural mechanisation released an abundant labour supply during the Victorian age. Contrasting images here are of an impressive office entrance above the image highlighting the process of destruction.

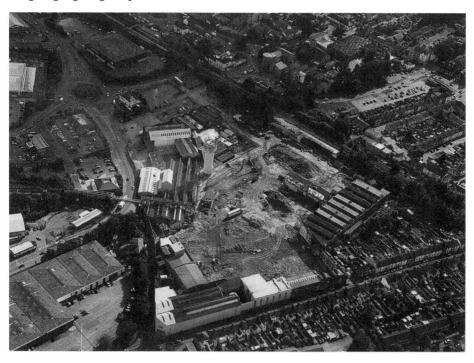

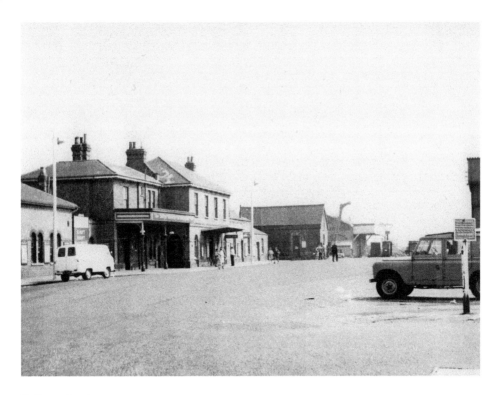

Railway Station

The railway came to Sittingbourne in 1858. It transformed the town and added impetus to industrial expansion. The old sleepy station yard is pictured above in the early 1960s. Vestiges of an earlier age of steam can be identified from the water storage tower on the right of the picture. Due for redesign, the controversial pattern of roads is planned to revert to a more pedestrian-friendly scheme.

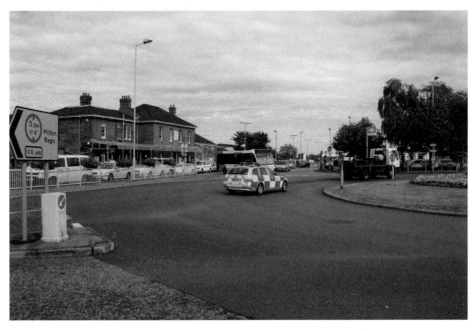

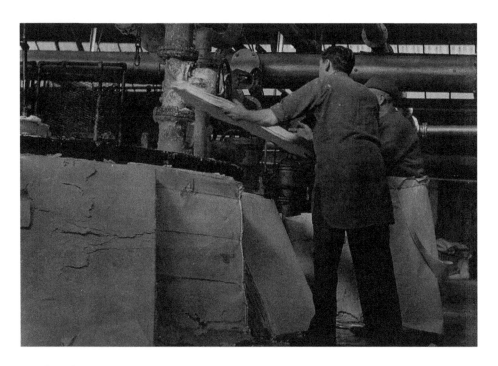

Local Crafts

Local paper and brick makers of yesteryear are shown in these old images. The main output of newsreel paper from Sittingbourne went to Fleet Street printers, whereas millions of bricks (made from open cast mined earth) were a necessary building material used for the Capital's massive expansion. Gangs of labourers, supervised by a 'moulder', worked intensively, using muscle power rather than mechanisation for their manufacture.

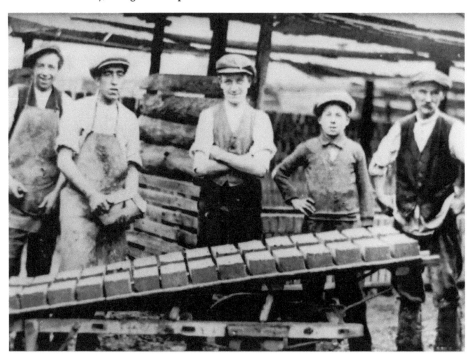

Royal Visit

The Duke of York visited Sittingbourne one day in the 1920s. He arrived with his entourage in an open-topped Sunbeam touring car. Many local industries and farms were inspected. Luncheon was provided at the imposing residence of estimable businessman George Dean whose business holdings included cement and brick making. Farming was another one of his sizeable investments. Today G. H. Dean and Co. Ltd has become a major well managed agricultural enterprise with fields and orchards surrounding peripheral housing estates.

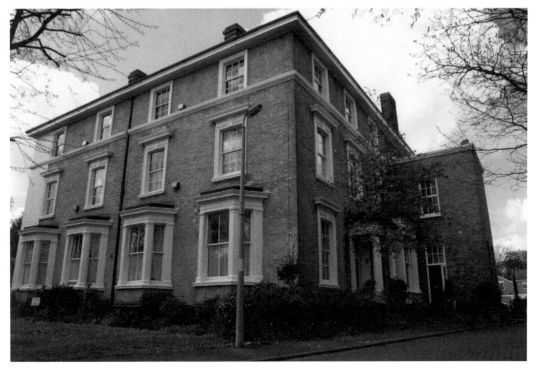

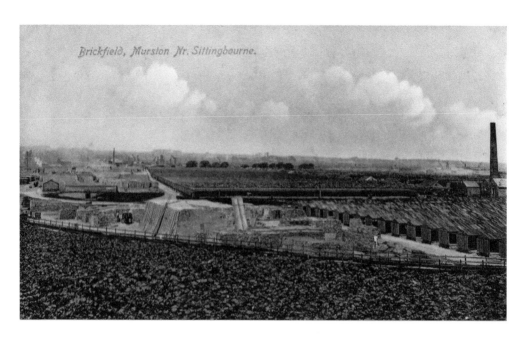

Brick and Cement Works

The localities' former massive scale of brick manufacture can be gauged from the postcard image above. Extensive areas shown in this picture were deployed for open air storage and curing. Below is a rare plate glass photograph from the very late Victorian or Edwardian era of Murston Cement factory.

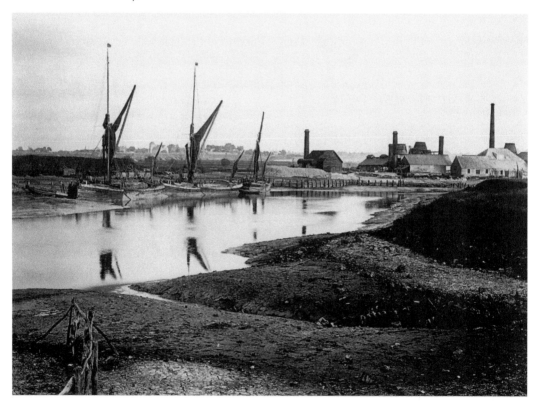

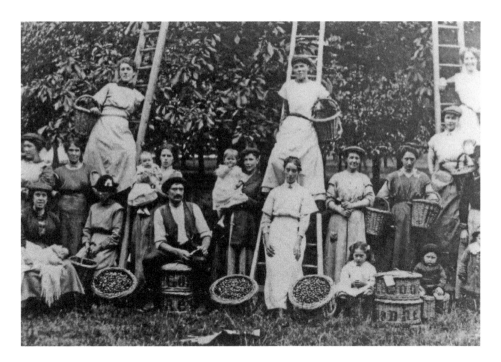

Fruit Growing

The pot lid illustrated here is a relic of Victorian packaging. Loads of these products were sent by horse-drawn transport to the firm's in-house barge and onwards to a warehouse in London. These pickers are seen in a Goodhew plantation at harvest time. Tall trees were then *de rigeur* with heavy, unwieldy ladders used to access the highest crops. Cherries are still grown in this area, following a tradition inaugurated by Harris, Henry VIII's fruiterer. However, they are produced on trees with short trunks and invariably under metal frames for protection from weather and birds.

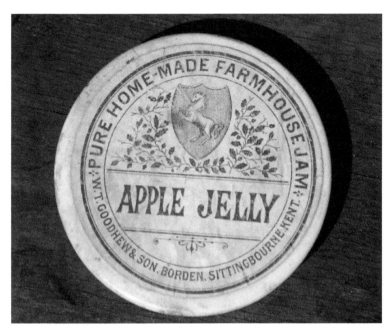

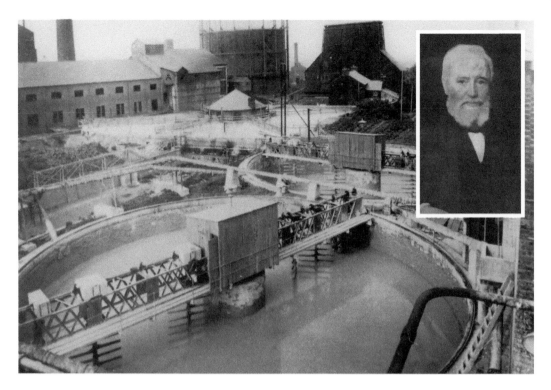

Smeed Dean

The firm Smeed Dean became renowned in Sittingbourne. Its founders were George Smeed and George Dean. The former had a more colourful reputation, whilst their major products, stock bricks (with the imprint SD) and cement, were highly rated. A reproduction of an oil painting of Mr Smeed is inset above over a mixing tank, whilst the toil of his workers is etched in the expression of their faces depicted below.

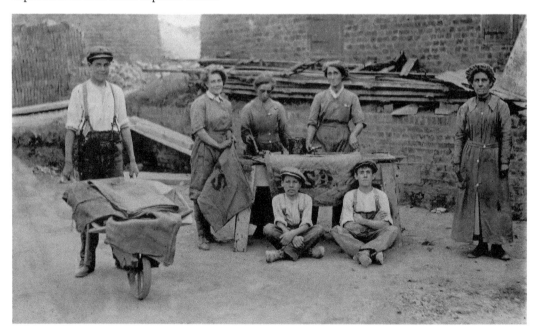

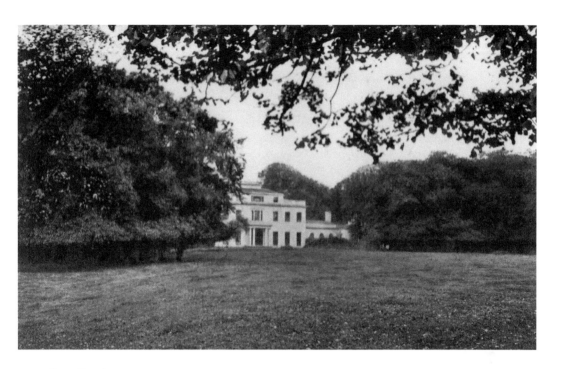

Gore Court

The palatial Palladian mansion named Gore Court was George Smeed's seat. Park Road, which was constructed at a right angle to the main road (now labelled A2), refers to this mansion's existence. The owner, a prominent local tycoon, was also a munificent employer who funded annual bean feasts for all and sundry in its grounds. With the apocalypse of the First World War, troops from the Dublin Fusiliers were encamped here exactly one hundred years ago in April 1915, before embarkation to French battlegrounds.

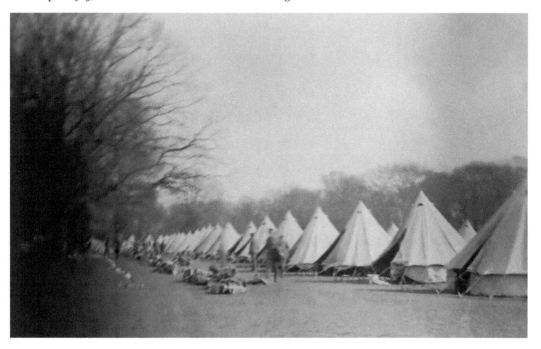

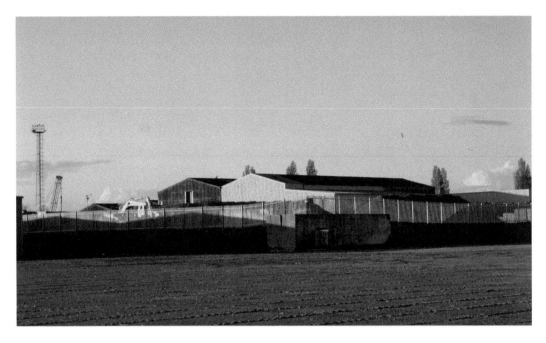

Milton Pipes

The photographs on this page are of the old derelict site of Milton Pipes adjacent to Cooks Lane, Milton Regis, and brand new buildings recently erected at their larger creek side premises. The latter has an extensive newly prepared groundwork site possibly cleared for further industrial development. Meanwhile, the defunct and almost abandoned work area is zoned for future housing.

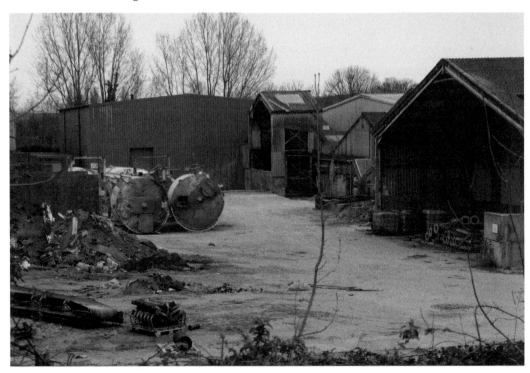

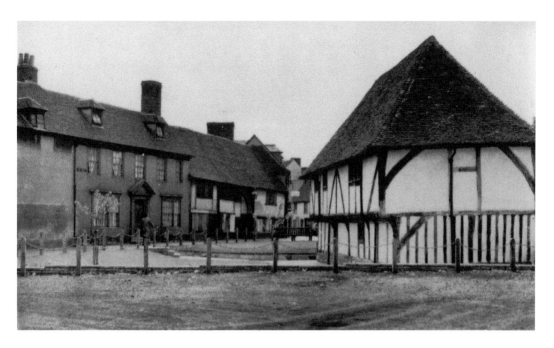

Court Hall Milton Regis

The Court Hall Milton was built in the fifteenth century for legal trials and imprisonment of offenders. Externally, timber framing and plaster infill reflects the architectural practice of late medieval times. Fortunately, this fascinating heritage building has just reopened to the public and is now managed by a charitable trust.

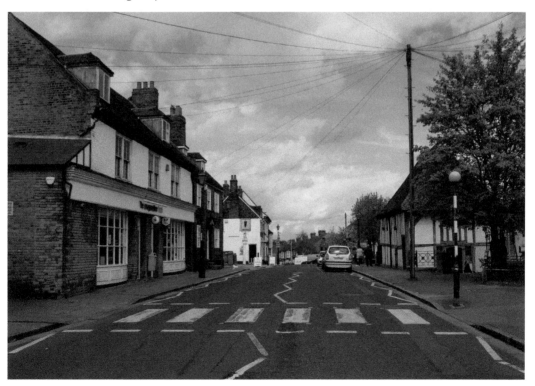

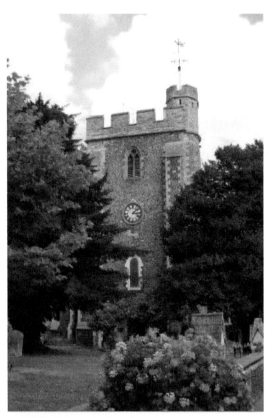

St Michael's Church

St Michael's church has served the community since perhaps Saxon times. Its present structure is a typical amalgam of medieval styles. In the late eighteenth century a devastating fire destroyed the roof. Thereafter it took many years for the town's congregation to fund restoration. Used now for regular weekly worship, this church continues to be a true flagship of the borough. Sadly, the fine vicarage below has disappeared to make way for new developments relating to St Michael's Road.

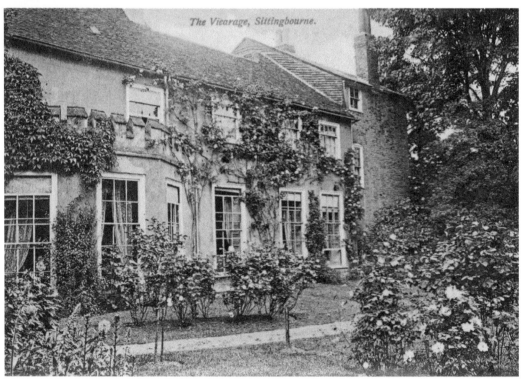

The Vicarage, Sittingbourne.

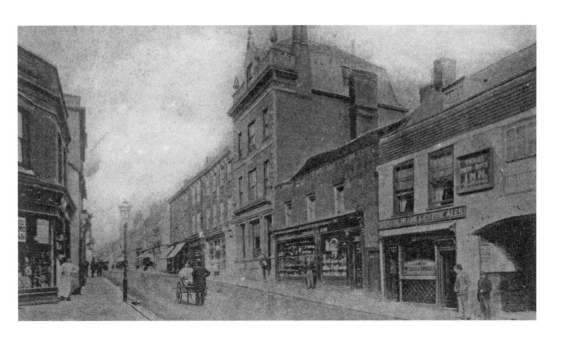

The Old Westminster Bank

The bank, with its shiny mahogany counters, used to operate from the buildings in the centre of this picture, before moving to the town hall site. For many years the baker's and cafeteria, run by the Barrow family, have been a convivial respite for shoppers. The gap in the buildings is the entrance to the Methodist chapel.

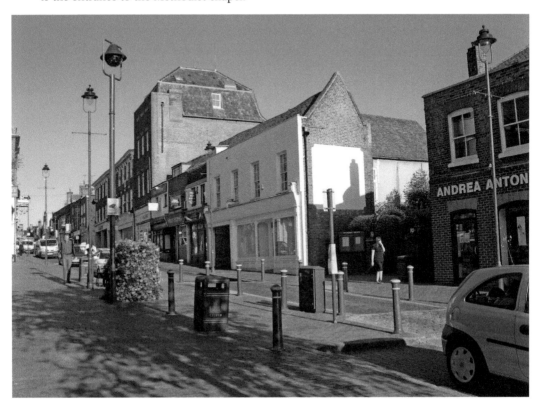

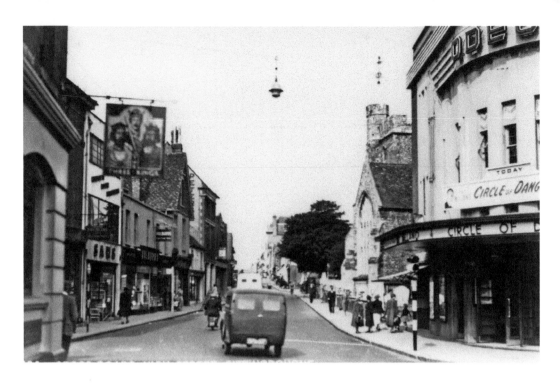

The Odeon Cinema

The Odeon Cinema was the last of three picture houses to close its doors on Sittingbourne film lovers but has since re-opened again. First to shut was the Plaza in East Street, followed by the Queen's nearer the main High Street.

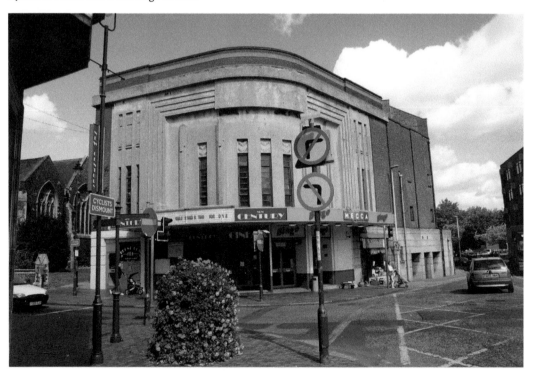

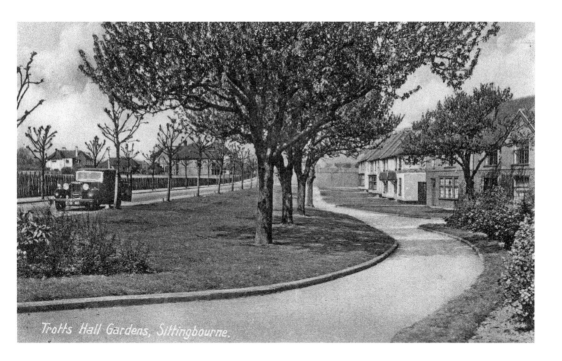

Trotts Hall Gardens, Sittingbourne.

Remembrance Avenue I

Trotts Hall estate was, as the name implies, built within the grounds of a larger residence. Due to redevelopment needs, this house was taken down brick by brick and remade in the grounds of Milstead Manor. It became a retirement home for the renowned local businessman, the late Rex Boucher. The avenue of young trees to the left commemorates servicemen fallen in the Great War. They have been replaced to accommodate widening of the roadway following a Sainsbury supermarket superseding Bull Ground football pitch (previously the home of Sittingbourne Football Club).

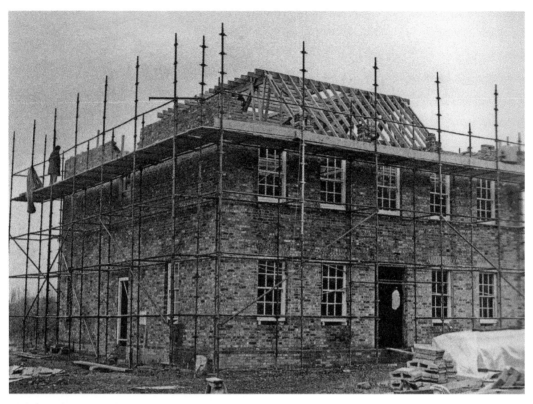

Trotts Hall
The archive photograph was taken during the hall's reconstruction and below with established gardens. The local builder, Butcher, was responsible for this skilled operation.

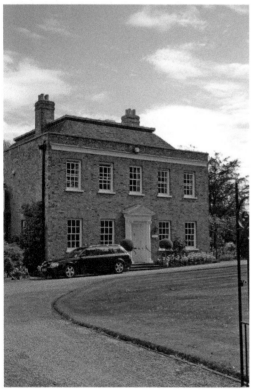

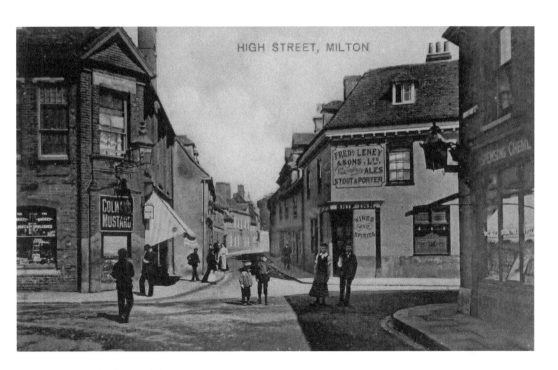

Bottom of Milton Hill

The classic Edwardian postcard street scene above is of the lower end of Milton High Street which led down to the Town Quay. One street corner business comprised a public house and the other a provision shop. Nearby, a coffee house also existed in former times to distract seamen and other thirsty labourers from more intoxicating beverages. Presently, decently designed flats for retired gentlefolks (called Tannery Court) occupy the west side.

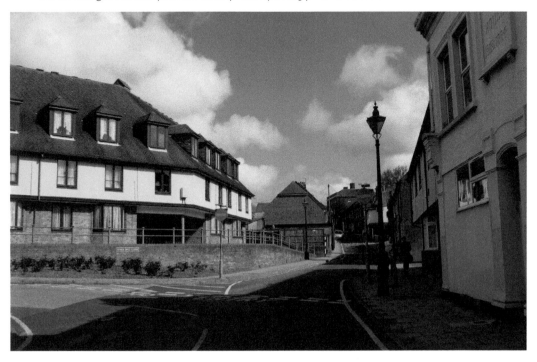

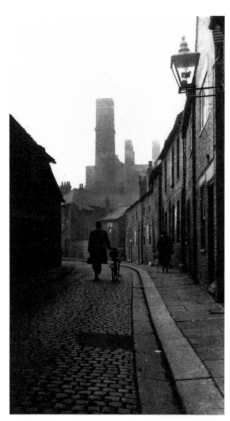

Lion Public House, Church Street
Conveniently placed next to the Sittingbourne paper factory was the Lion public house. This substantial 'boozer' was handy for shift workers. Below it has become a large home. The beautifully composed atmospheric sepia photograph, above for comparison, was taken at a close spot back in the time when common personal transport was more likely to be a bicycle. It echoes dark, but not satanic, mills.

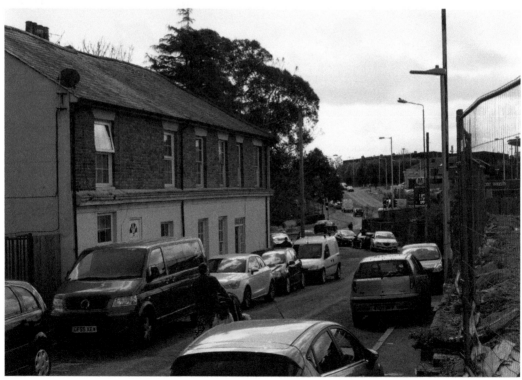

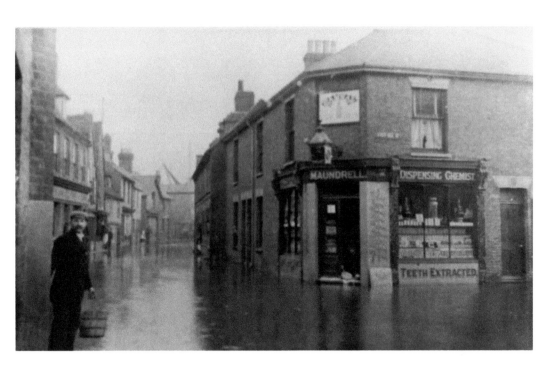

Floods

The pictures here are of low level roads adjacent to Milton Creek head. At high tides the area floods. Above, the waters were a foot deep surrounding Maundrell, chemist and 'something' of a dentist in Kings Street. Many of these terraced buildings were demolished to make way for Mill Way. Even in 2014, residents of Tannery Court were evacuated as a precautionary measure when seawater lapped across the present roundabout.

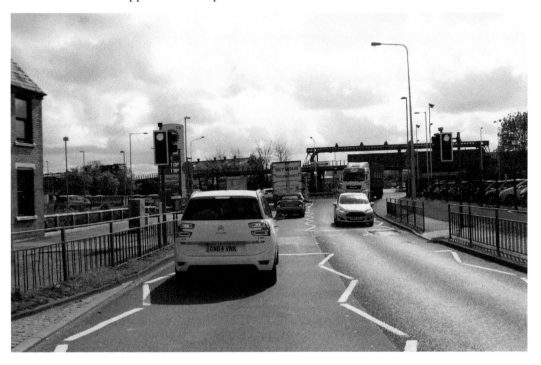

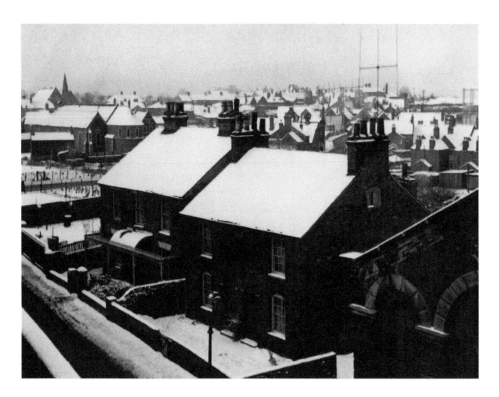

Church Street

Starkly contrasting pictures of change can be seen on this page. The old triangle of Pauls Street and Church Road below once encompassed a forest of chimney pots belonging to Victorian houses. These, along with St Pauls church, have been razed to the ground and replaced partly by industrial works of a major heavy door manufacturer.

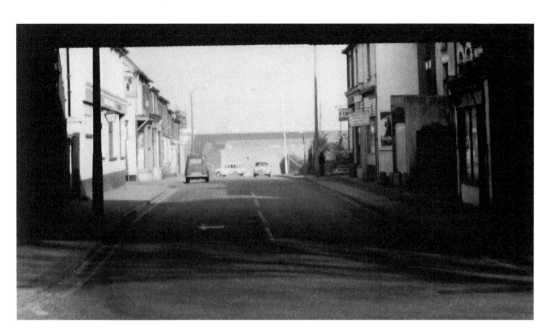

Milton Road

Framed by a railway bridge near Sittingbourne's main line railway are these two transformational pictures. Looking northwards, the old image has monolithic brick warehouses relating to storage of paper raw materials. To the west the Railway Arch pub still stands, while its erstwhile competitors on the other side, named Peace and Plenty and the Wyfe of Bath, have departed. William Morrison's supermarket is now on the left and opposite is a depot for public service vehicles. Most significantly, a retail park is viewed ahead with its pseudo brick kiln referencing the town's traditional brick making activity.

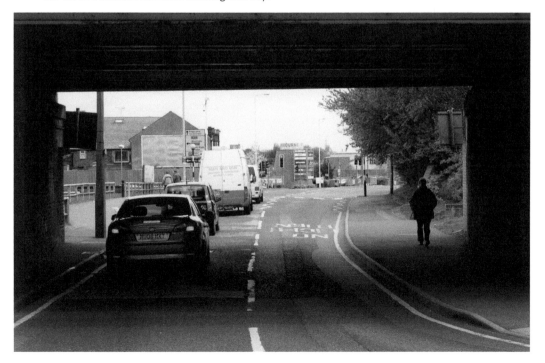

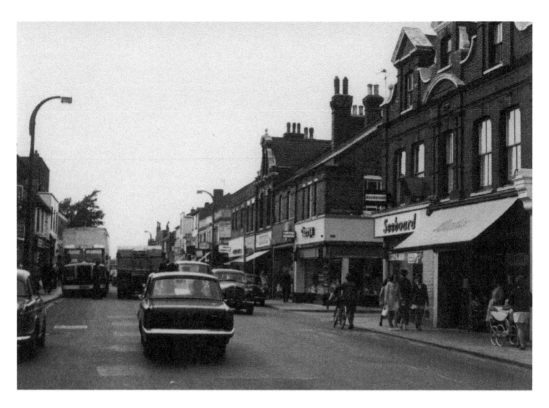

The Mid High Street Looking West

This view is remarkably unchanged since the 1960s – save for the nature and merchandise of the various shops. Looming above the skyline in a recent photograph is the department store built by the Co-operative Society. This emporium on the corner of Station Street has been taken over by a discount store, namely Wilkinson Plus.

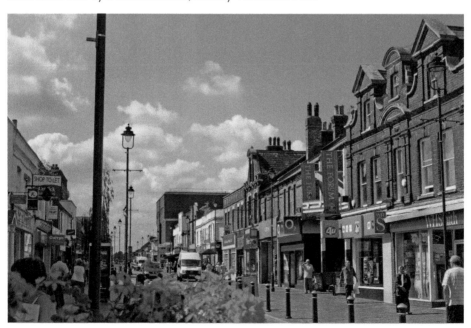

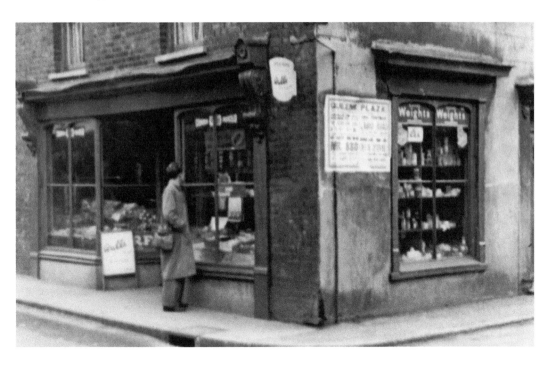

Old Shops

One of Milton Regis's archetypal corner shops of yesteryear is exemplified above. Their convenience to consumers has gone full circle with the UK's largest retail group Tesco re-establishing this method of sales through its Metro outlets. Below, a recycling firm was in operation in East Street. Similarly, this form of commerce stays perpetually useful.

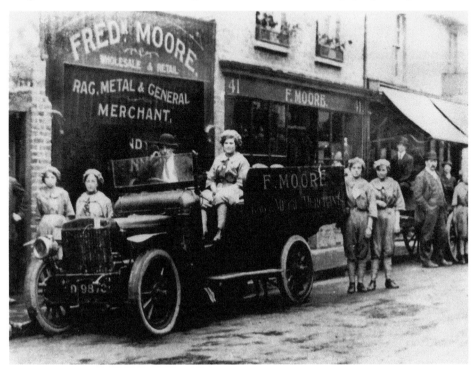

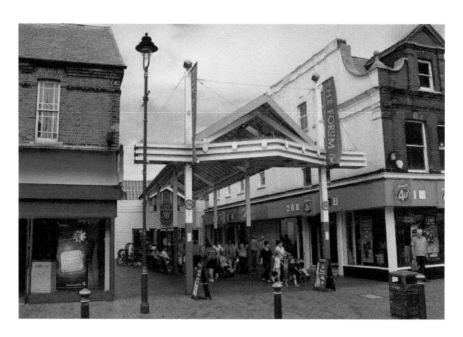

Crescent Street, Looking North-East

On this side of Crescent Street an electricity supply company had a showroom. Adjacent to this, concealed behind two wooden doors, was Harry Down's garage. This was a one-man band outfit with an Esso fuel pump dispensing fuel at below 5s a gallon.

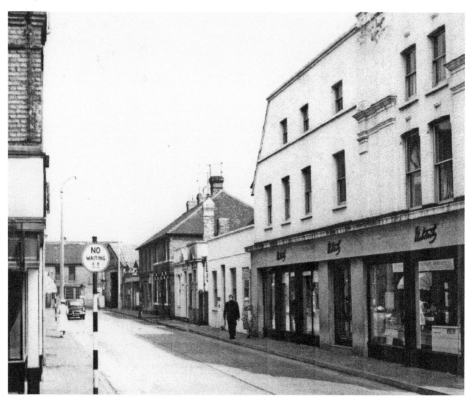

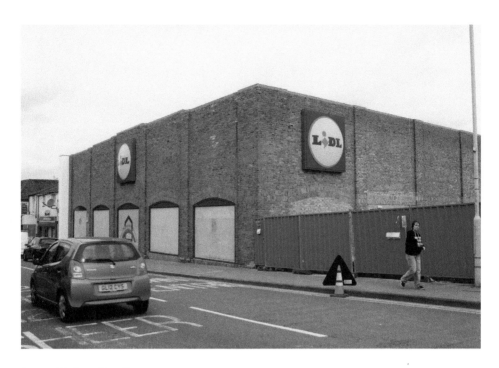

Large Modern Retailers

Soon there will be two major discount supermarkets in town. The first edition of this book title (2009) mentioned Aldi in East Street. Its sister competitor, in every sense, will be Lidl. It will open shortly on the previous site of Focus and Pullen's garage West Street. Meanwhile, William Morrison at the old Sittingbourne Mill site fears greater competition, but has already experienced a visit from the company's new chief executive who is anxious to turn around profitable prospects.

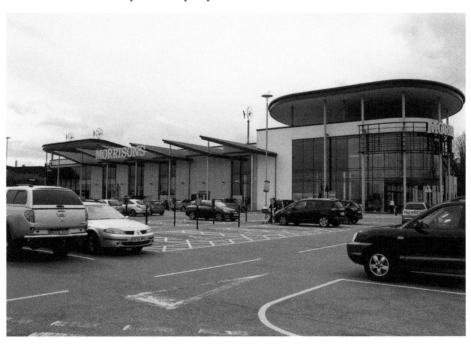

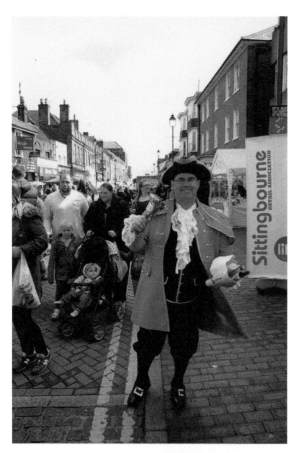

Street Celebrations I

A jovial town crier announces a St George's Day 2015 street party in the main thoroughfare. Even more emphatically heralded by a brass band is the Co-operative Society's demonstration of a lost age. Its organised march and leading banner is a reflection of past social solidarity, notwithstanding the joy of a day's holiday.

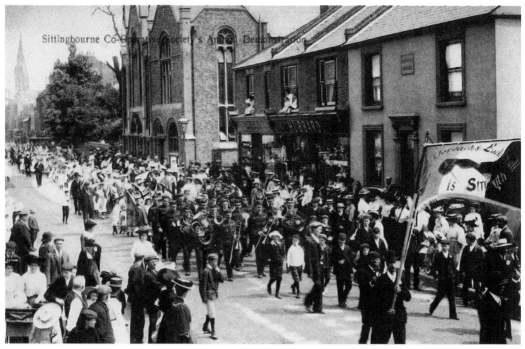

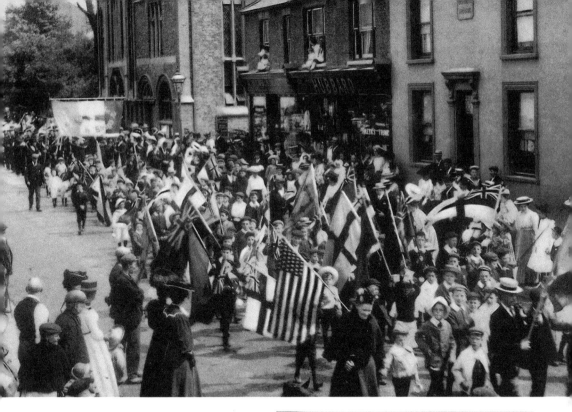

Street Celebrations II

The portrait snapshot (adjacent) of Sir George and his Dragon shows a flash of the flag of England. Patriotically it is also seen midway in the parade above. Proof surely that it's not just the totem of the barmy army England football supporters et al.

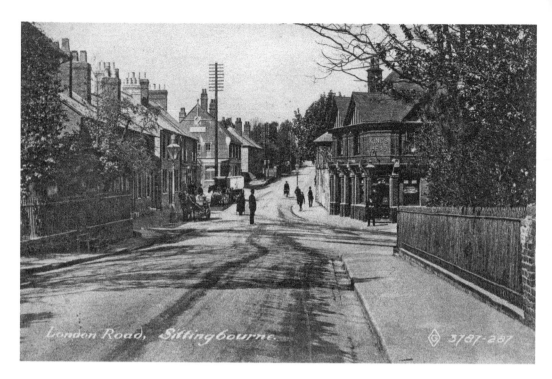

Chalkwell

Chalkwell was, before the Industrial Revolution, a separate community from Sittingbourne. It was known for its tannery – one of several in the vicinity. Also, a windmill once ground corn on the nearby hillside. The iron railings on the right of the picture above have now been replaced by a wall, concealing a sheltered housing development. Meanwhile, the King's Head public house, prominent on the corner, remains as a club.

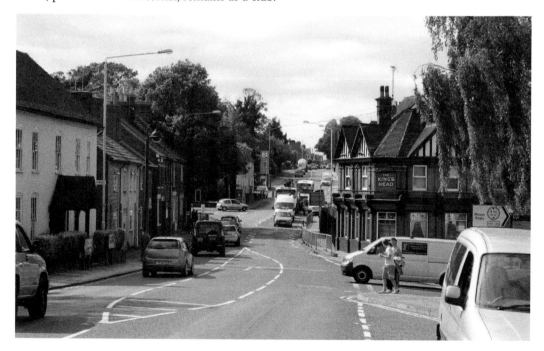

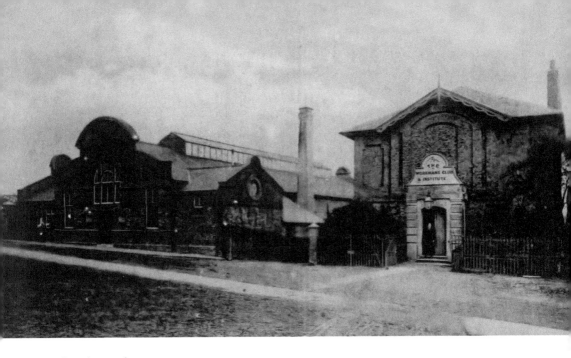

Swimming Baths

Local historian Bryan Clark created much nostalgic interest when he posted the below image of Sittingbourne's old swimming baths on the internet. Hundreds of people responded including, potentially, myself who received instruction here as a ten year old schoolboy in 1960. District council leisure facilities became enhanced by the 1980s when Swallows Leisure Centre near Central Avenue was opened. Grey and dreary Victorian buildings above were accordingly collapsed. The vacant land subsequently became St Michael's Motors – principle local second-hand car dealers.

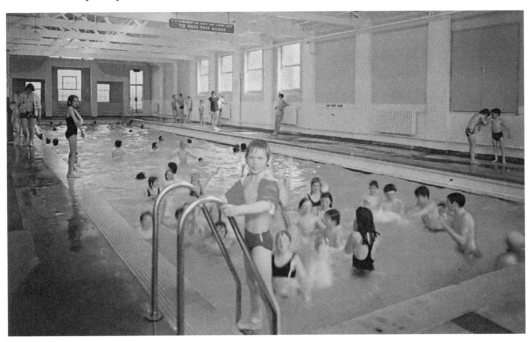

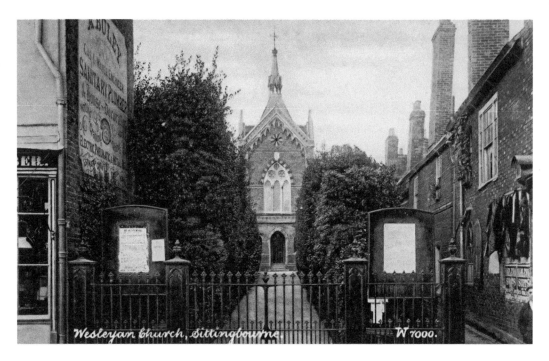

Methodist Chapel

The opulently devised and sumptuously furnished interior of this mid-Victorian church was hit by incendiary bombs during the Second World War. Engulfed by destructive flames, it had to be replaced by its plainer replacement in the 1950s.

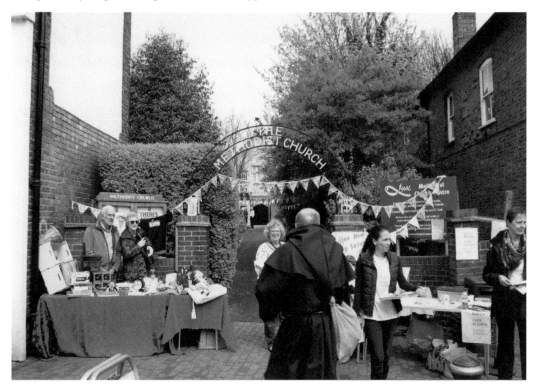

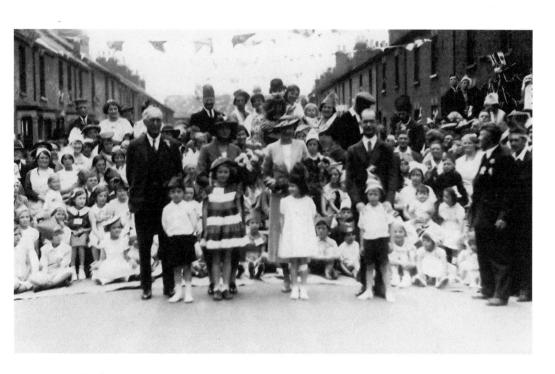

Street Parties

Juxtaposed here are two photographs of street parties. In the below image, re-enactors are very appropriately dressed in chivalric armour for St George's Day, whereas above coronation celebrators in Goodenstone Road are most conventionally attired in their best outfits.

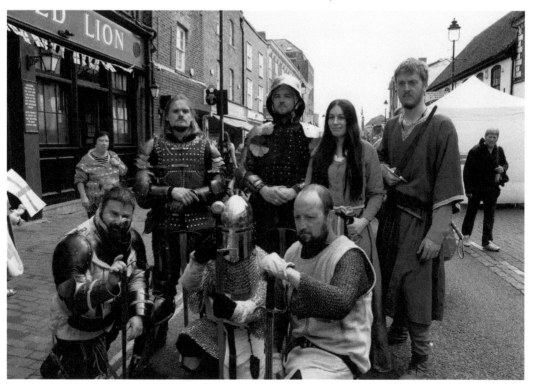

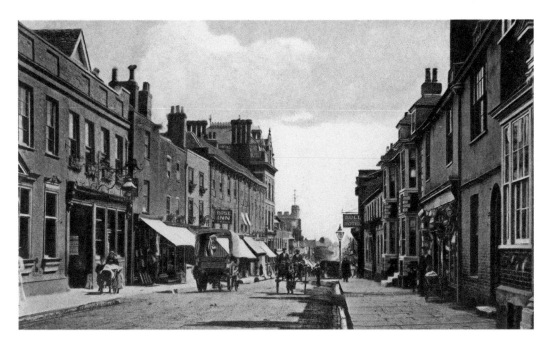

High Street Looking Eastward

This section of the High Street, where the gradient falls eastwards, is where the town's first settlers lived. Eventually, inn-keeping was the predominant economic activity. The most sumptuous was Rose. Still standing resplendently on the northern side of Watling Street/A2 in the previous edition of this book (2009) Woolworth had just vacated these premises. Its present use is currently resolved by 99p's occupation.

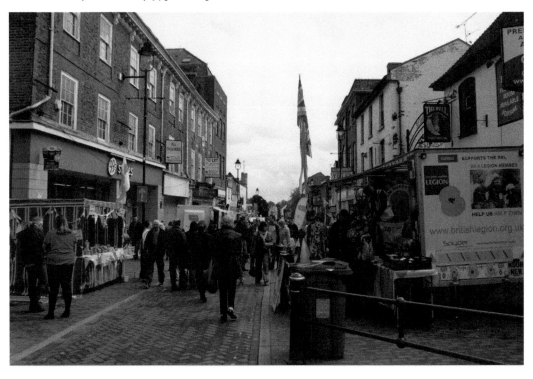

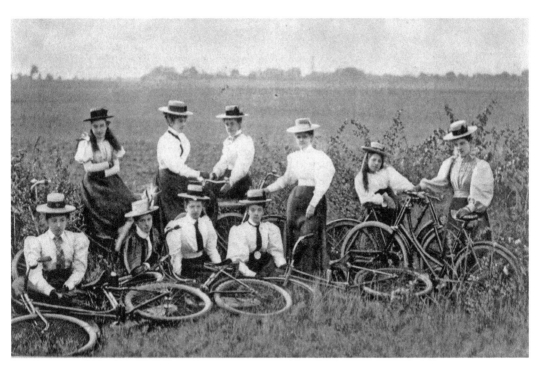

Pastimes

Rammel, the leading Sittingbourne photographer, took this snapshot of late Victorian young ladies out cycling for recreation. A go-karting circuit on the Eurolink estate is now a venue for more contemporary fun.

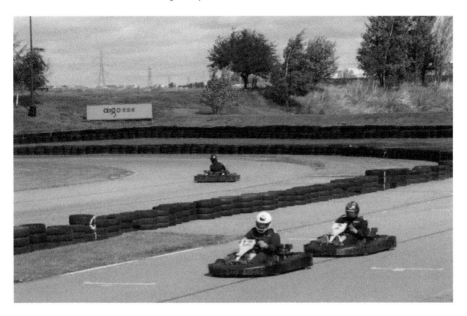

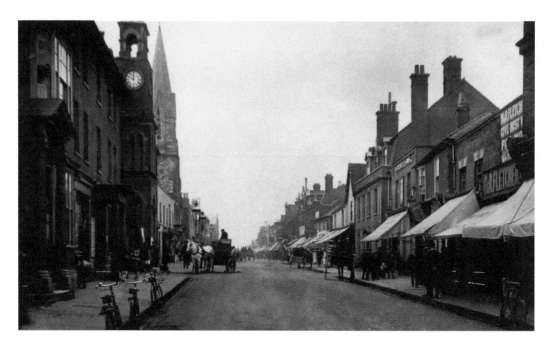

High Street's Northern Façade

Canvas awnings were almost universal fixtures on shop fronts of Victorian emporiums. These features are excellently depicted in the outstanding period camerawork above. Sittingbourne was no exception to this trend. Substituted buildings in this northern section of the High Street now include Burtons (art deco) and Halifax (neo-Georgian).

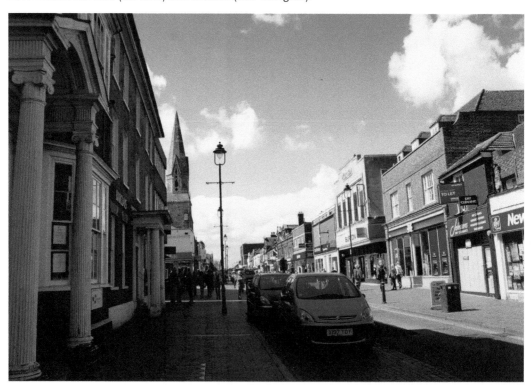

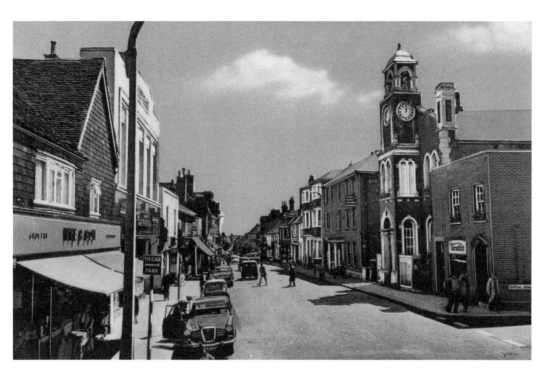

Former Town Hall

One of the last professionally taken shots of Sittingbourne's old Town Hall is seen above. It was first designed and used as a corn exchange. Now the corner site houses NatWest Bank. Unfortunately for such an axial position, its unimaginative elevations do not enhance nearby Georgian architectural treasures.

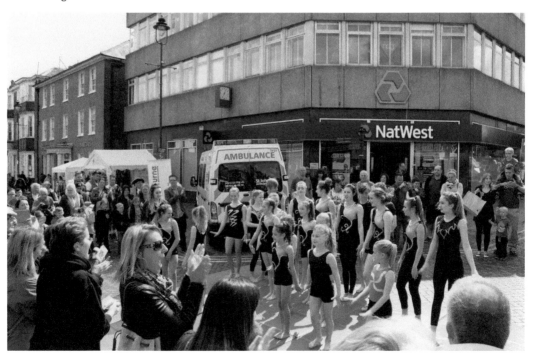

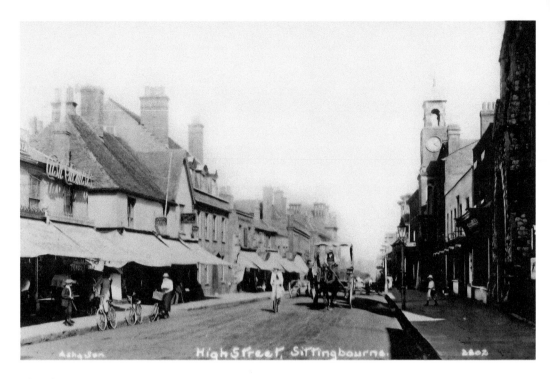

Chemists

Across the road from the old town hall westwards was a pharmacy called Boots Cash Chemist. On this northern side of the High Street Boots has had a long term presence. In the contemporary image below custom car enthusiasts have parked their show vehicles near the familiar logo and colour of this long running drug and toiletries corporation.

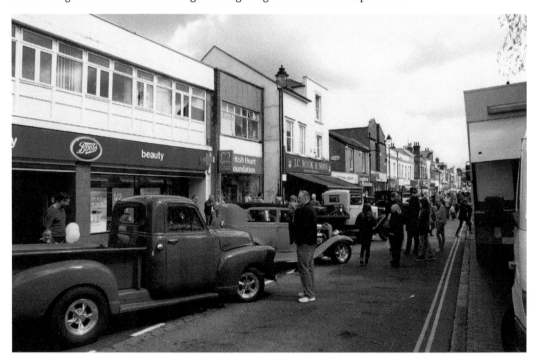

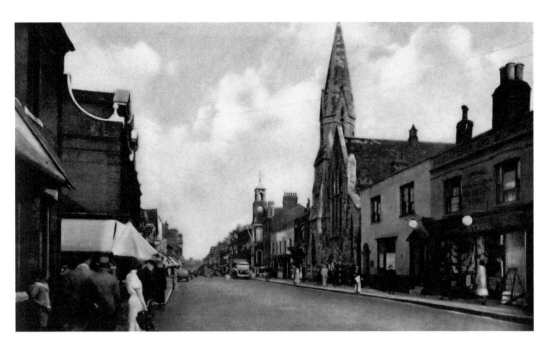

United Reform Church

Affluent non-conformist Victorians built a church on the town's highest point to worship their Congregational denominated religious beliefs. Their aspirations were well interpreted by an architect whose tower exudes linear beauty and grace. Some of the continuous terraces of buildings between the old town hall and this church made way for Central Avenue in the year of this author's birth, 1949.

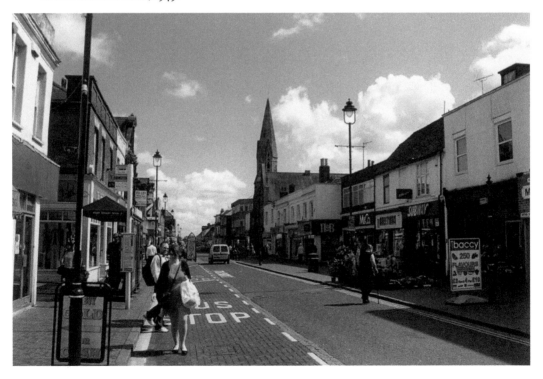

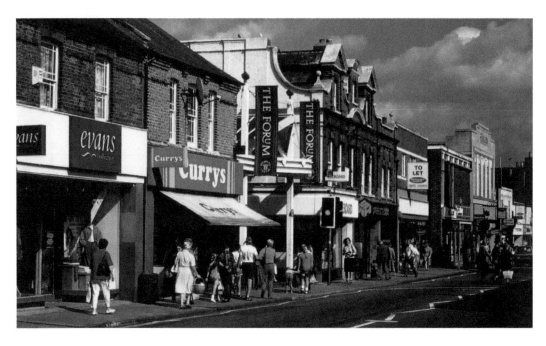

Entrance to 'Old Crescent Street'
Sittingbourne's enclosed shopping mall known as the Forum (after the town's ancient Roman links) was developed over Crescent Street which was an access road to the railway station. The now dated picture above provides evidence that shopping patterns have changed, with discernible less bustle here.

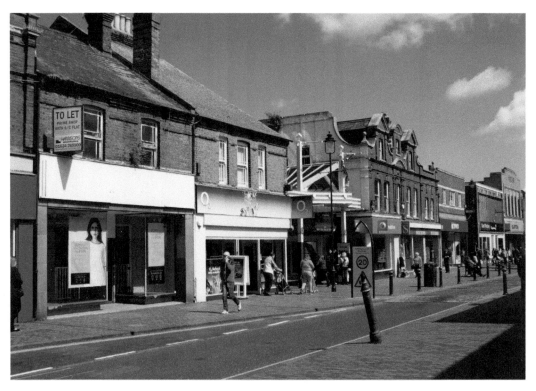

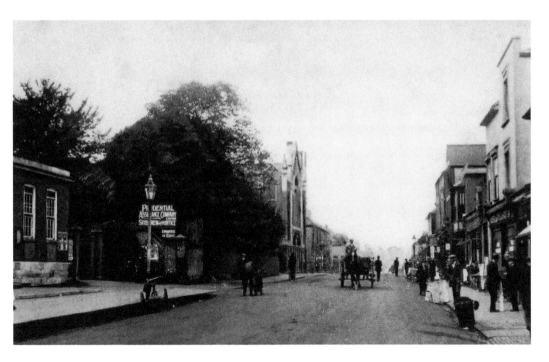

Sittingbourne's Second Post Office

Royal Mail's operational base moved up hill from opposite St Michael's Church in 1911. Its larger facilities were adapted from a substantial residence called Polvenors. Childhood memories of its interior are of heavy serving counters and a gritty utilitarian concrete floor.

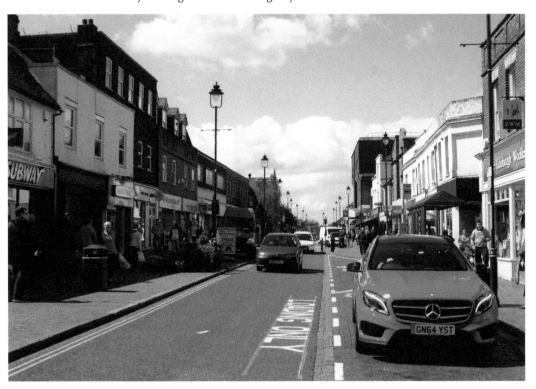

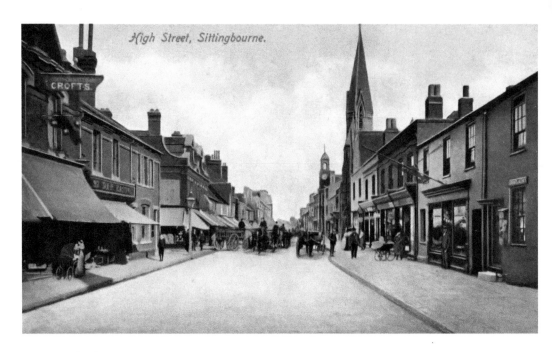

High Street, Sittingbourne.

Dan Eason's Shop

The early pictorial postcard above is of pinpoint prospective. Apart from its technical merits it can be dated by the boy's suit, horse drawn vehicle traffic and most interestingly the fascia sign of Dan Eason's shop at Number 32. Within living memory furniture both new and second-hand was sold here. A 1930s family car from the next generation is lined up above for admiration at a recent rally.

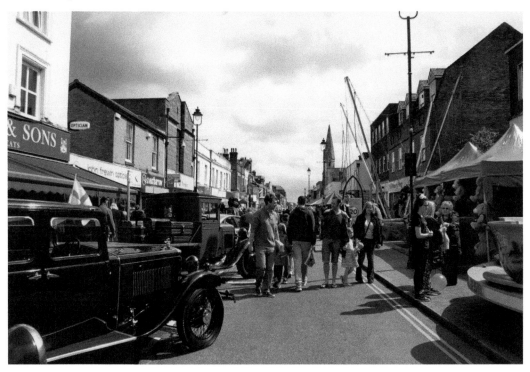

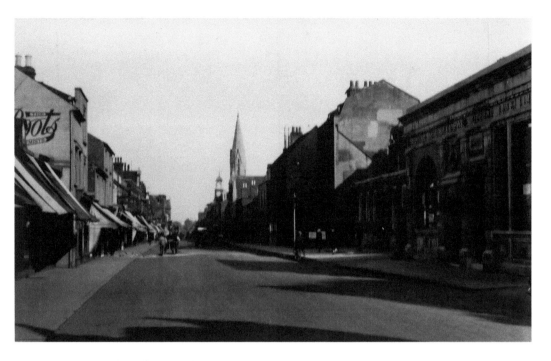

Prudential and Midland Bank

The august offices on the far right of the scene above were knocked down around the 1970s. Midland Bank, which became insolvent in the early 1990s banking crisis, moved to 115 High Street and is now subsumed into the UK's largest clearing bank, HSBC. Behind this frontage was a club converted from a house called the Cedars. It was frequented by a generation of post-war youth for meeting, socialising, imbibing, dancing and generally relishing the joys of their age. Many sentimental sighs accompanied its demolition in 1971.

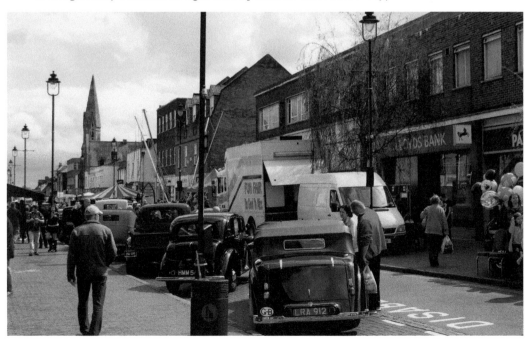

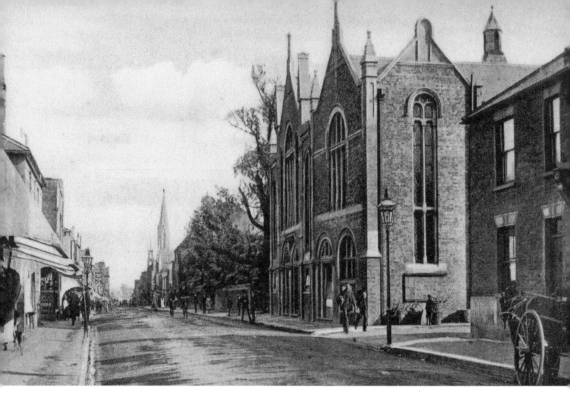

Baptist Tabernacle (Number 1, West Street)
Surprisingly, this Victorian church is the town's largest in terms of seating capacity (800). Preachers are sure to be inspired by its theatrical gallery. Today it has a multi-use for nursery infants.

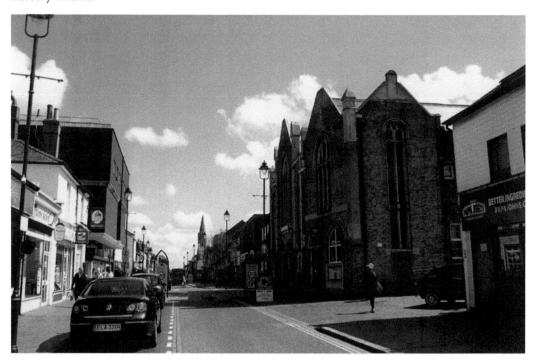

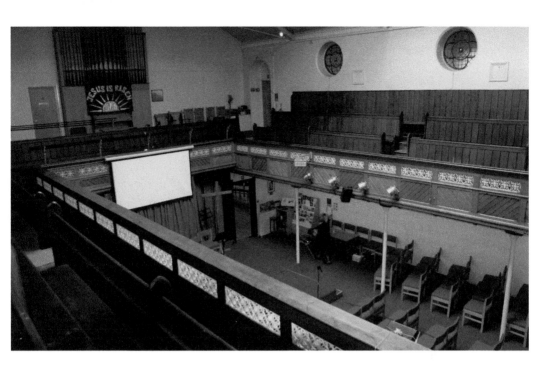

Baptist Tabernacle

Thankfully, on visiting this important asset to the local community I was guided by Hazel Waters. She described how without external grants major roof repairs had recently been completed. Below the brass plaque commemorates a previous stalwart. The Revd John Doubleday had a legendary forty-year career here. His ancestors became the estimable local farmers with extensive well managed orchards and fields lapping the urban perimeter.

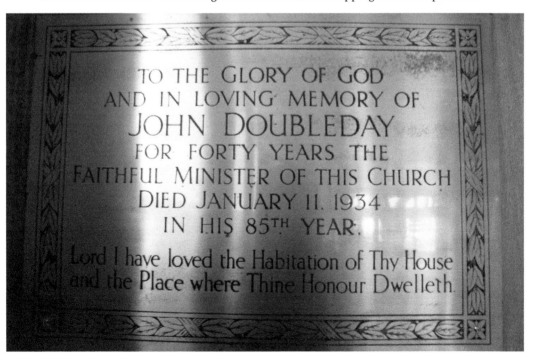

TO THE GLORY OF GOD
AND IN LOVING MEMORY OF
JOHN DOUBLEDAY
FOR FORTY YEARS THE
FAITHFUL MINISTER OF THIS CHURCH
DIED JANUARY 11. 1934
IN HIS 85TH YEAR.

Lord I have loved the Habitation of Thy House
and the Place where Thine Honour Dwelleth.

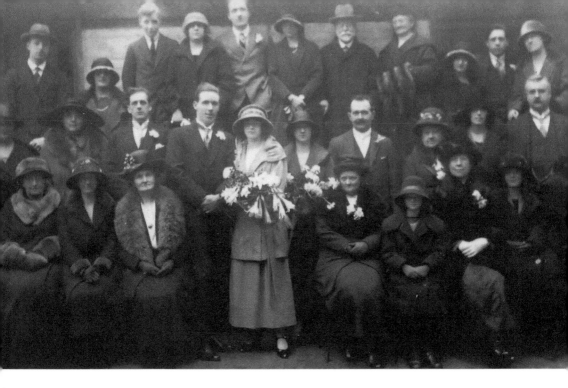

The Wicks family

The wedding photo above is of the union between Tom Wicks and his bride Joyce Goodhew in 1924. Brother of Theo, Norman and Bernard, this oldest scion of the Tong Mill dynasty suffered imprisonment by Germany during the First World War. His bravery and ingenuity helped him to escape. In later life his wily quiet ambition meant that he acquired a desirable home – Loose Water Mill – and raised a son who became a vet that married the daughter of writer H. E. Bates of *Darling Buds* fame. Tong Mill, coated with a clean blanket of snow, is shown below.

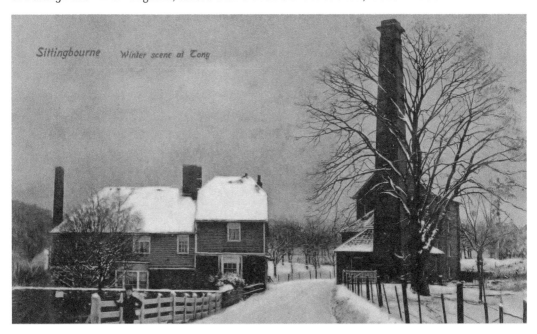

Sittingbourne Winter scene at Tong

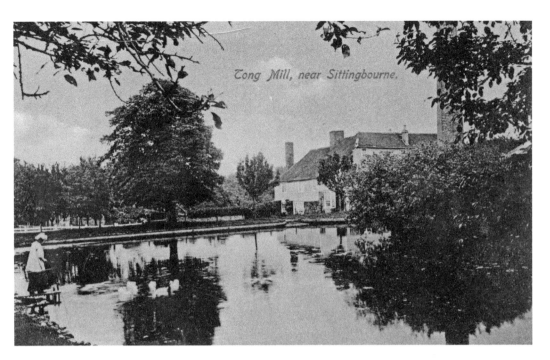

Tong Mill, near Sittingbourne.

Tong Mill

Tong Mill is one of four Conservation Areas illustrated in this volume. Its classification is a vital protection as urban sprawl creeps inexorably closer. Once the site of a Saxon castle, this unchanging gem of the Kent countryside is fortuitously surrounded by countryside park, generously provided by its long-term owners, the Wicks family.

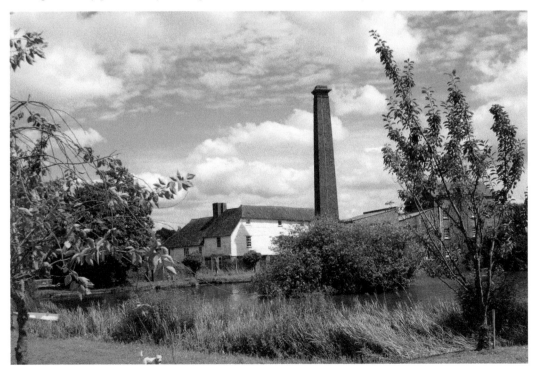

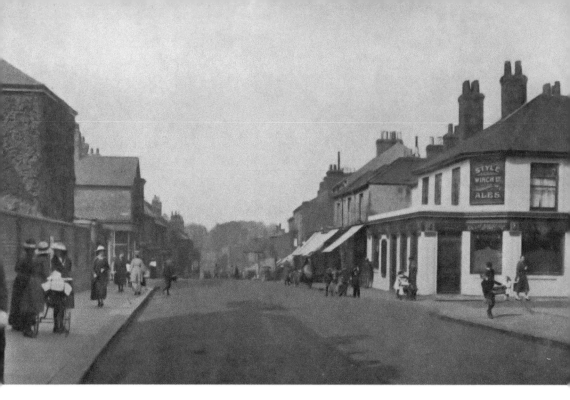

West Street

The public house on the right of West Street called Ypres Tavern was named thus because of legions of local soldiers who fought on the Salient at Ypres during the various battles of severe attrition which affected this Belgian city in the First World War.

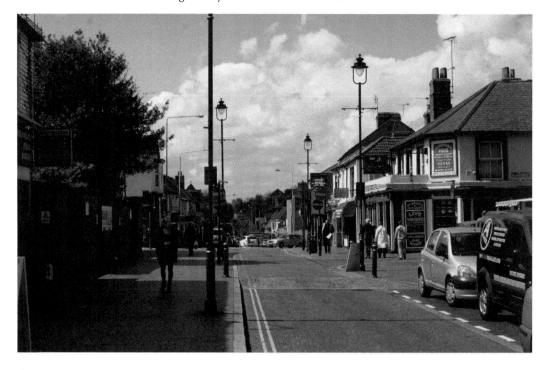

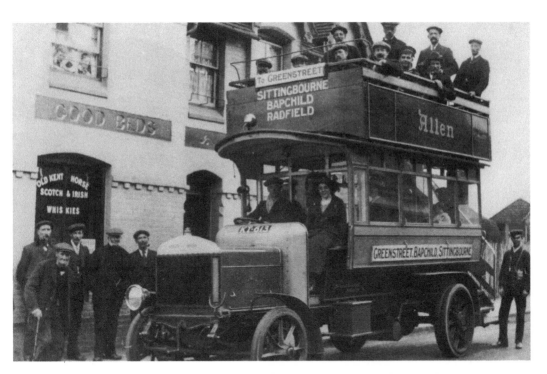

Brickies' Outing

Local brick workers of yesteryear would recognise this recent picture of reject bricks in front of a pile of excavated brick earth. In the shot above, however, they have their minds on some well earned recreation as they eagerly prepare for an outing on a double-decker bus.

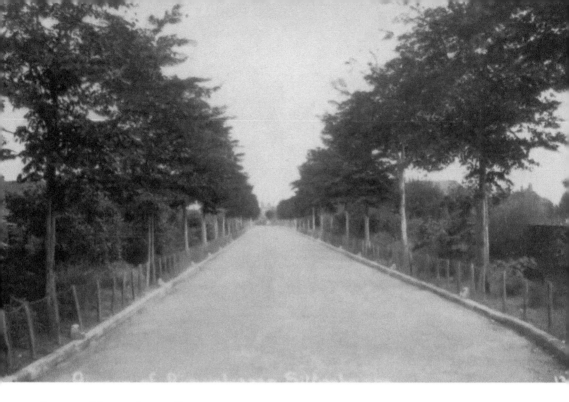

Avenue of Remembrance II

The rustic picture above is an early record of Sittingbourne's touching and imaginative tribute to its fallen dead in the First World War. These lime trees were, over the decades, pollarded and roots expanded to tilt commemorative name plates. When J. Sainsbury developed a supermarket store on the old Bull football field, the trees were grubbed. Afterwards road widening hornbeams replaced them and can be seen to be flourishing.

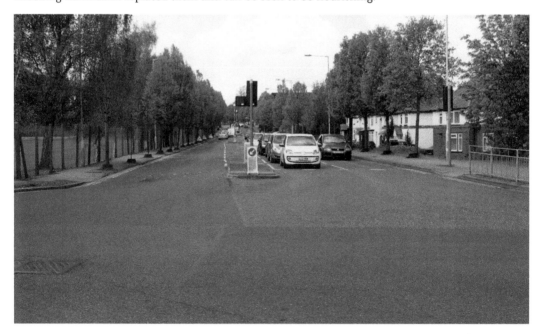

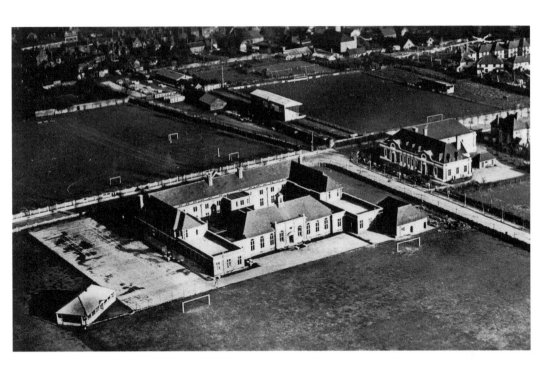

Borden Grammar School

The aerial sepia print above is a good view of the then new Borden Grammar school with its classic quadrangle. It stood magnificently surrounded by playing fields. Later the Swallows Leisure Centre and ex-council chambers were placed in front and opposite its neighbour (Bowater's Leisure Club), the previous town football field, became a J. Sainsbury store.

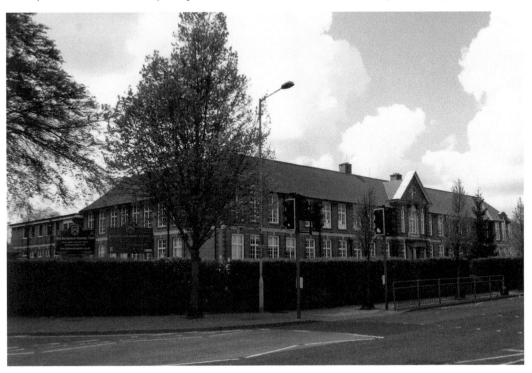

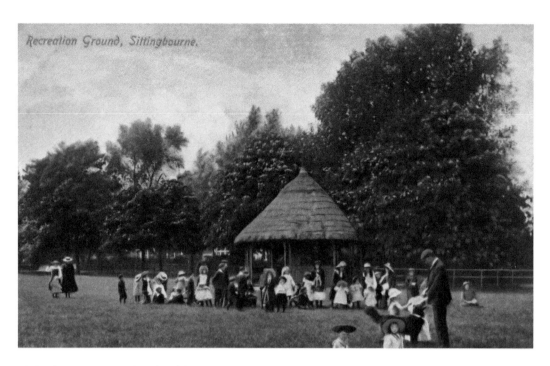

Recreation Ground, Sittingbourne.

Sittingbourne Recreational Field

Deserted under a showery April 2015 sky, the populace turned out in force with garden party gaiety maybe a century earlier. A vignette of Edwardian childhood is glimpsed in the well composed photograph above. At this juncture, the town's largest open space boasted a thatched roofed summer house. Cynically, one wonders how long this might presently survive vandalism.

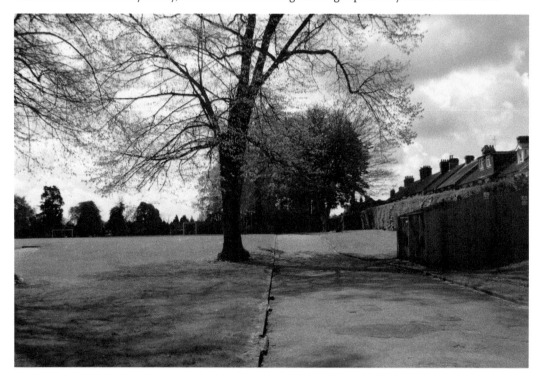

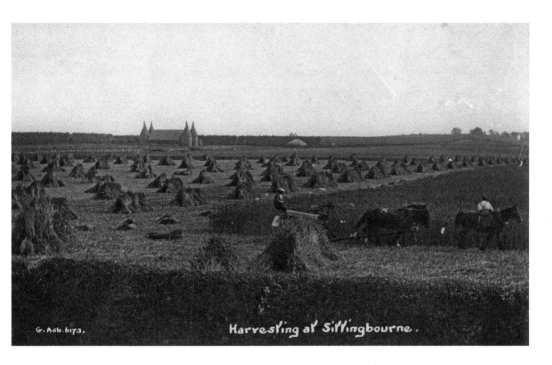

G. Ash. 6173.

Harvesting at Sittingbourne.

Harvesting Near Sittingbourne

Farming has always been a significant economic activity in the Swale area. Sittingbourne is placed in the middle of the North Kent Horticultural Belt. A good climate, fertile soils and a nearby metropolitan market have been favourable factors. Within living memory, sheaves of corn were harvested for threshing later after careful storage in neat stacks. Leviathan machines now combine cutting and threshing and leave nothing but dust and particles of straw in their noisy wake.

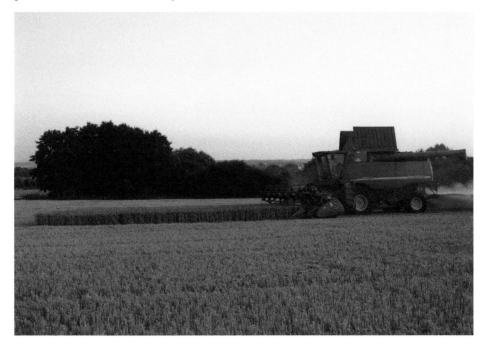

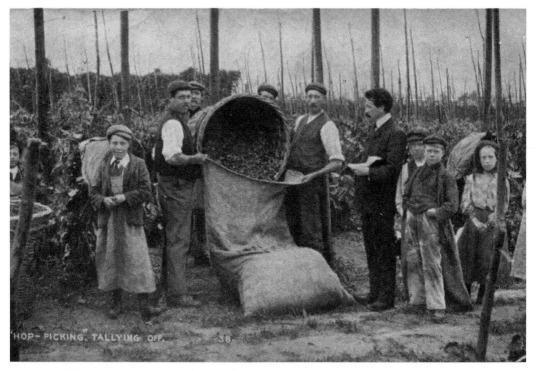

HOP-PICKING. TALLYING OFF. 38

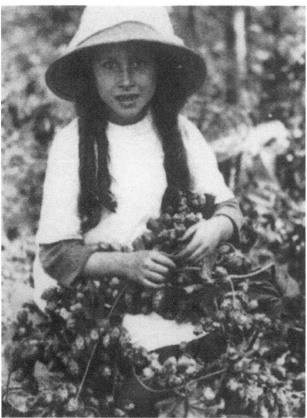

Hop Pickers
Dorothy Francis helping
towards the harvest at
Broadoak Farm, Milstead.
Pictured in her childhood,
she became a very much
respected member of her
local community and enjoyed
participating in village
activities until near the end of
her long life.

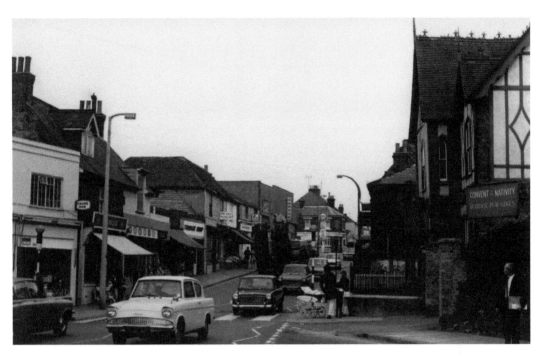

West Street looking eastwards

These images display the major changes in this part of Sittingbourne over the past half century. Behind the 1960s stream of cars descending West Street was Pullens Garage (soon to be a Lidl store). On the right the Convent of Nativity school has been replaced by low-rise flats.

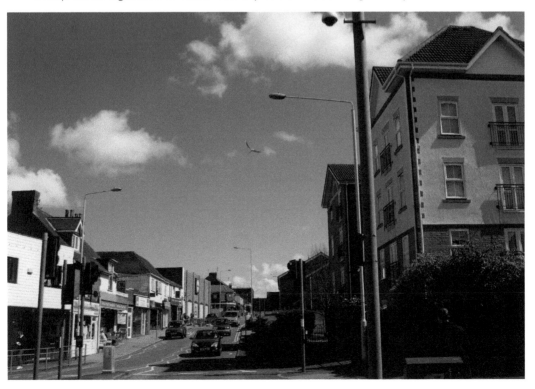

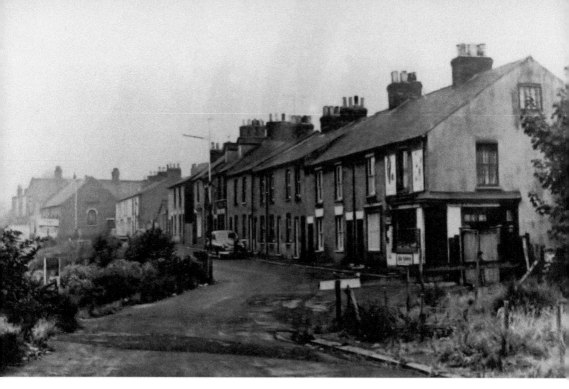

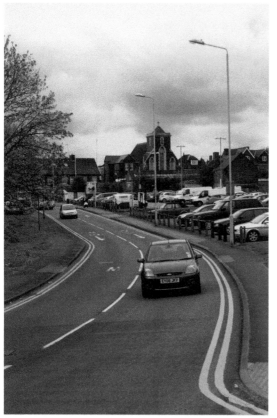

Cockleshell Walk
All the modest terraced housing and a typical corner shop viewed above in Cockleshell Walk were flattened to make way for commuters' car parks. The cycle is, however, about to turn full circle. Apparently, high-density flats are expected here soon!

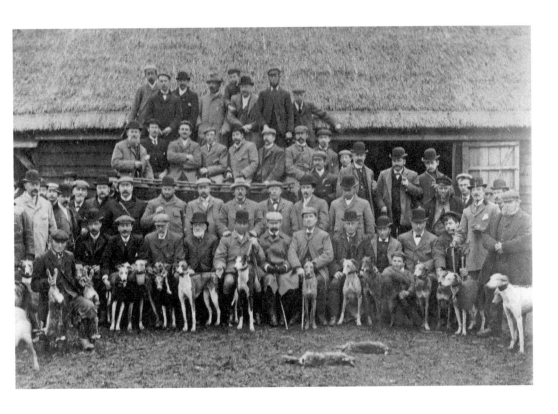

Field Sports

Hare coursing participants at Iwade near Sittingbourne around the turn of the nineteenth century. Below, a group of local men during a break from shooting in woods near Doddington some thirty years ago.

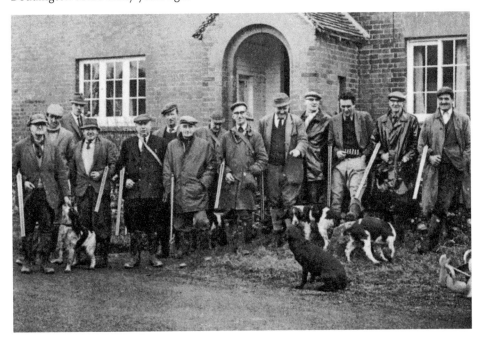

Old Forge War Time House

Like a 'tardis' one walks through
time from the entrance of Character
Costumes, East Street, into the Old
Forge War Time living museum.
Auspiciously, I visited this exciting
reconstruction of a Second World
War home on 70th anniversary of VE
Day. Welcomed by Debbie White, she
was snapped cheerily smiling while
descending steps into an authentic
copy of a bomb shelter.

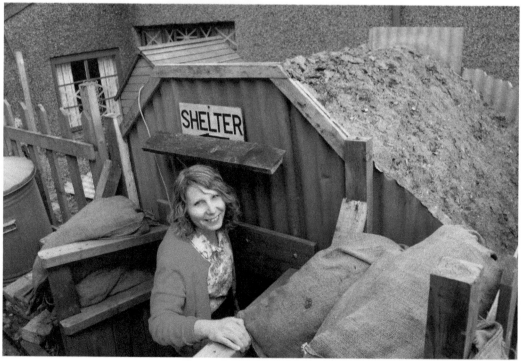

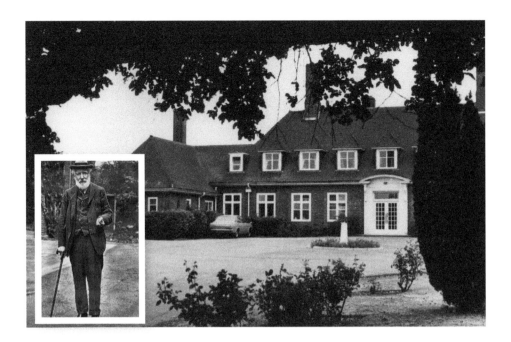

The Memorial Hospital

The Memorial Hospital was gifted to the town by local paper maker Frank Lloyd. Ludicrously threatened with closure during the early 1980s, the political fallout was so potentially enormous that it had the reverse effect. It has expanded into an even greater asset for Sittingbourne. This well run site comprises a doctor's surgery, pharmacy, a minor injuries unit, and nursing accommodation. It is also the venue for clinics run by peripatetic, specialist medical consultants. Inset is benefactor Frank Lloyd.

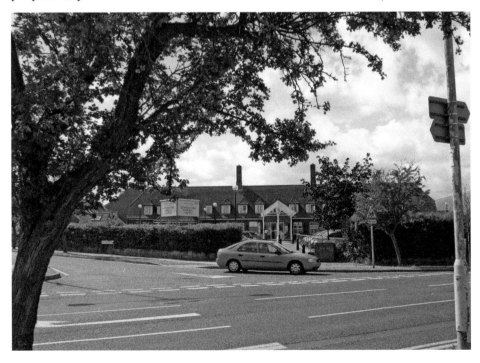

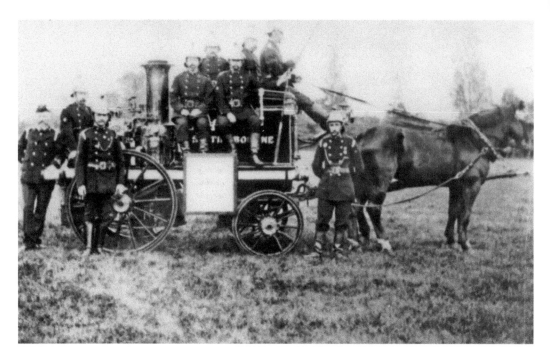

Fire Fighters

Headly Peters' champion fire-fighters and their horse-drawn pump in around 1900. This gentleman was a well respected businessman whose activities included selling travel tickets to potential emigrants. By contrast Sittingbourne's newest fire appliance is shown out and about on duty.

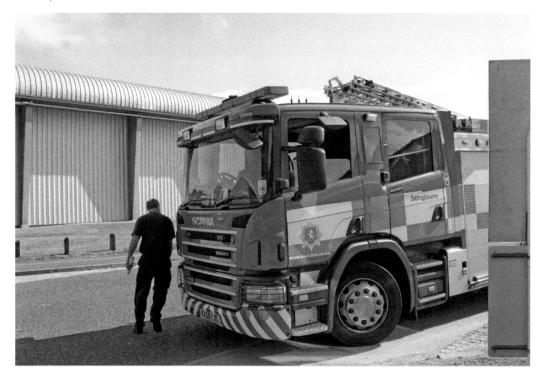

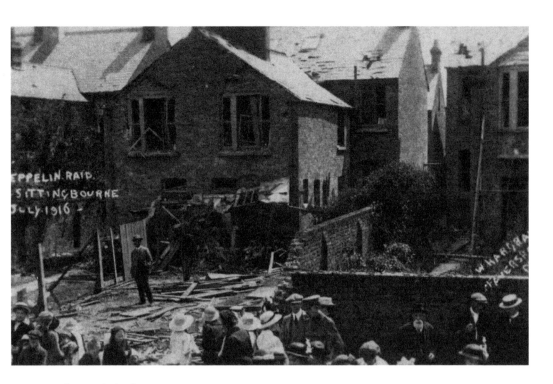

Bombs on Sittingbourne

Sittingbourne's close proximity to German airbases made it vulnerable to wartime air attack. The picture above indicates damage from Zeppelin bombs in Unity Street off Park Road. To promote propaganda and restrict panic the postcard below was issued, ridiculing dangerous air raids.

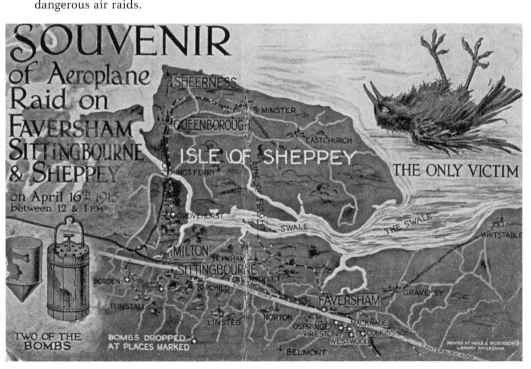

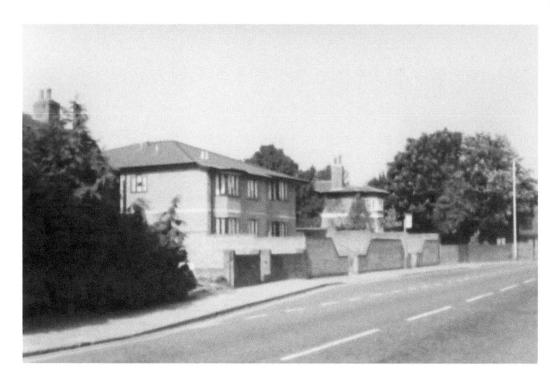

Chestnuts Doctors Surgery - East Street

The picture above shows the Chestnut surgery in the distance. In the forefront a modern building providing warden accommodation for elderly people has been replaced by one for social housing. The former was called Plaza Court – referencing the Plaza Cinema which stood here. The doctor's surgery converted from an unusual residence owes its soubriquet to the variety of trees nearby. Inset is the face of Sister Jocelyn Watson who has been a practice nurse here for twenty-five years.

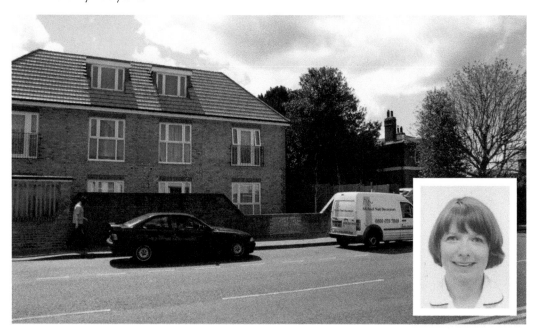

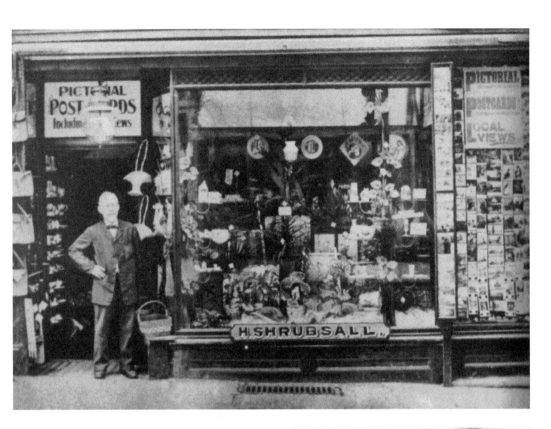

Shrubsall the Stationer

Shrubsall Stationers and Photographers in Sittingbourne High Street was one of an illustrious group that included Ramell, Bennet and Ash. These men deserve particular tribute in this book. Like the clerk in Chaucer's *Canterbury Tales*, they warrant special recognition. It is their efforts which ensured a record for future evaluation. On the right is an image from a typical postcard sold in Mr Shrubsall's shop. Soldiers camped or billeted in the town prior to embarkation to the battlefields of France often sent them to their loved ones. Following post office deregulation they became the e-mails of their time.

Sittingbourne would be a different place, If I could only see your face.

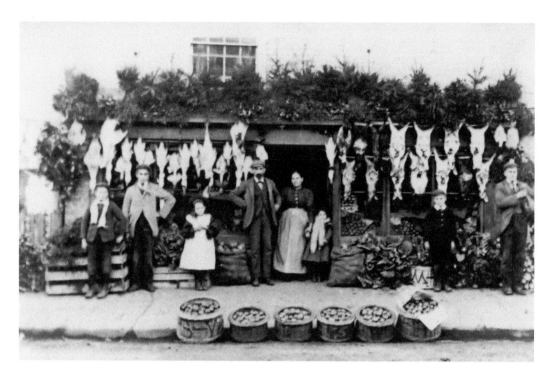

Butchers East Street

The composed photograph above is of a general food store. Later it specialised in butchery under the proprietorship of the Pittock family and then, through marriage of his daughter, to the Wades. Following closure, this charming period building was converted to provide an attractive home.

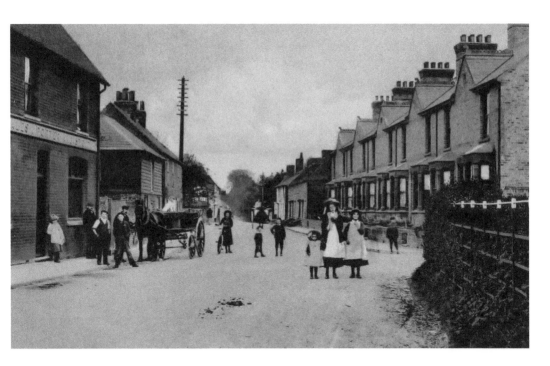

Bapchild I

Looking eastward in the carefully arranged picture above, a horse and cart was the largest road goods vehicle of its day. How it would surprise those erstwhile villagers if they were to see a modern forty-tonne lorry bearing down on them at this section of road.

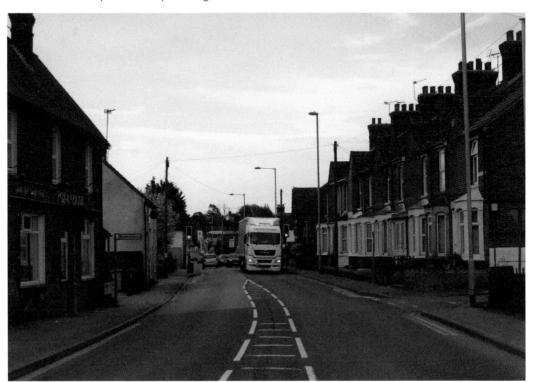

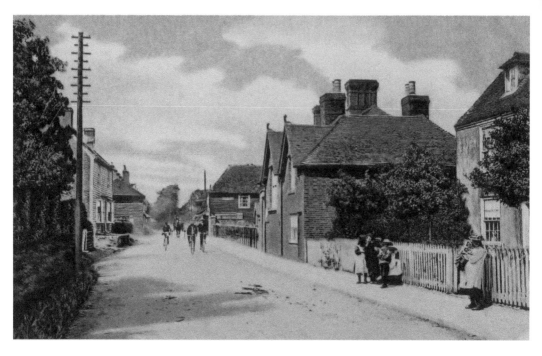

Bapchild II

Viewed from the west, the main road towards Sittingbourne at Bapchild above had a rustic appearance. Early photographs such as these were actually set up with precise artifice although they succeed in giving a natural appearance. Some of the houses lining this part of Watling Street had traditional wooden clapperboard elevations. The double gabled house to the right was damaged some years ago when a passing farm trailer caught alight.

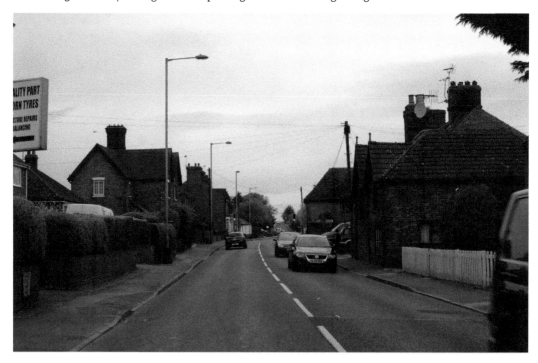

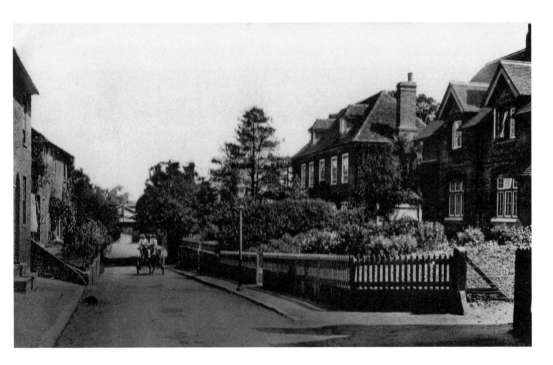

Newington Byway

Newington is a large village to the west of Sittingbourne with similar strong links to earlier Roman occupation. The charming illustrations, old and new, on this page both feature old fashioned means of personal transport. Above, a jaunty trap is propelled by a keen pony and below is a vintage car enthusiast giving his 1930s saloon an airing.

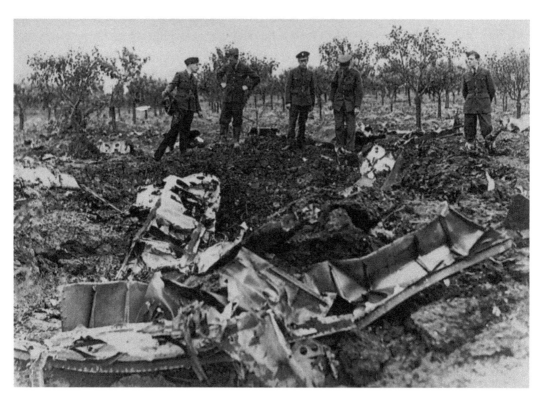

Memories of the Second World War

Here are two classic scenes of the Second World War period in Swale. First of all, a crashed German plane at Bicknor. Below, Land Army girls help to boost food production.

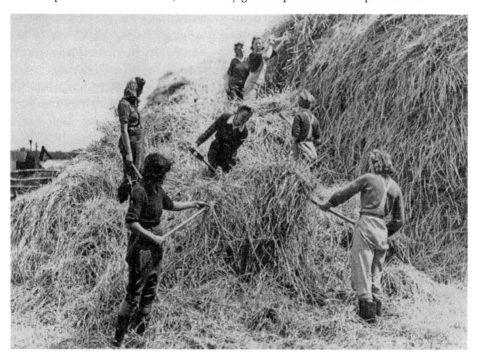

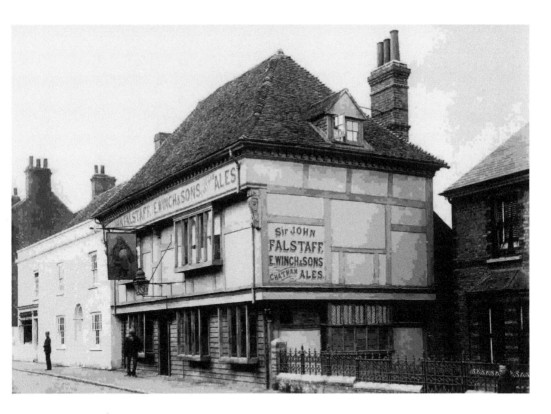

George Newington

The first published photograph above is of the Falstaff public house Newington. It was renamed the George and very badly wrecked by fire. Upon sale to redevelopers for around £50,000 it has become two homes.

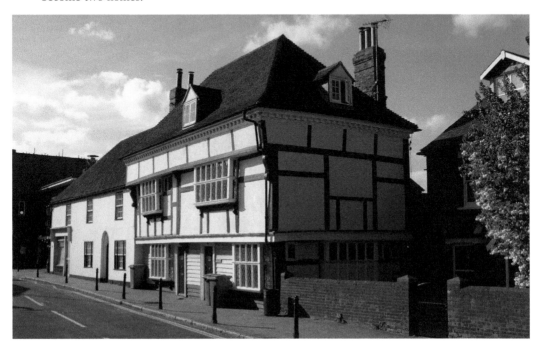

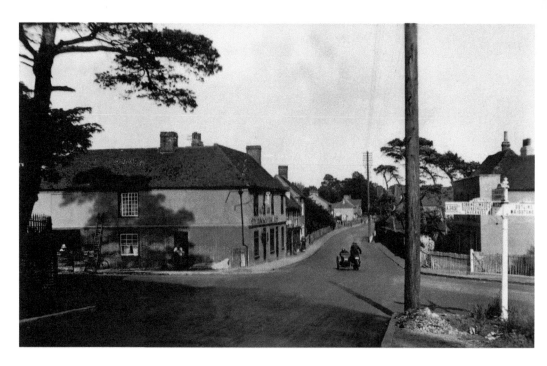

Key Street

The leafy image above belies the massive civil engineering works which have created an underpass of the A249 below the A2. The vision for this project was articulated by respected local farmer and former Liberal councillor Tom Ledger in his maiden speech upon election to office.

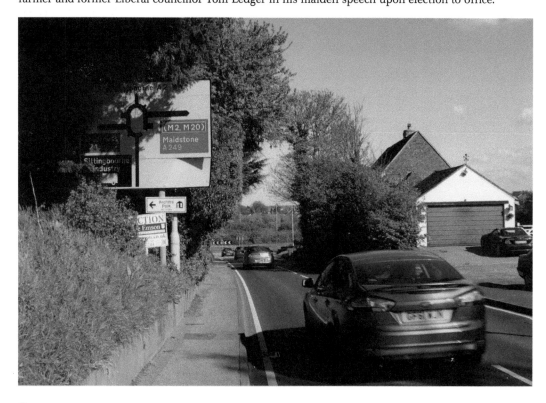

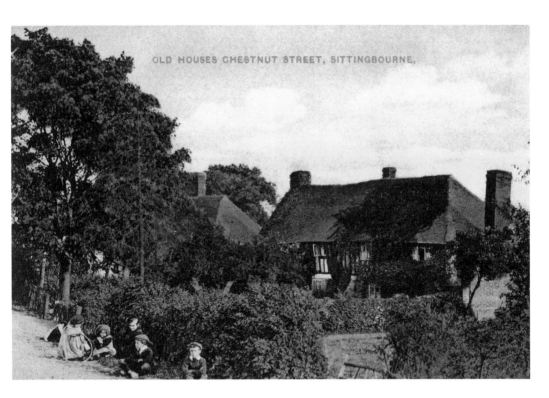

OLD HOUSES CHESTNUT STREET, SITTINGBOURNE,

Chestnut Street
A row of beautiful timber-framed houses lines the old road to Maidstone close to its junction with the A2. Belsom's chestnut fencing business operates in the vicinity. A very much earlier extractive industry nearby was gravel mining.

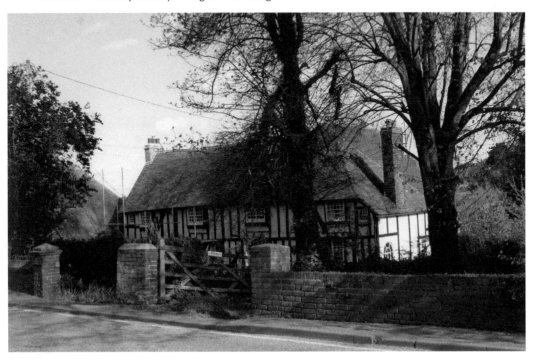

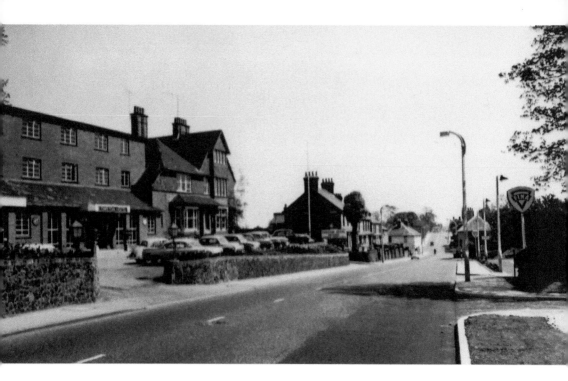

Coniston Hotel

Originally developed by a hard-working migrant family, this well-loved hotel paradoxically became the target of nationalist conflict during its inoperative period before adoption by a well managed leisure group. The controversy was caused by Government proposals to open a hostel for illegal immigrants here against tough 'nimby' opposition and even more violent demonstration by the National Front.

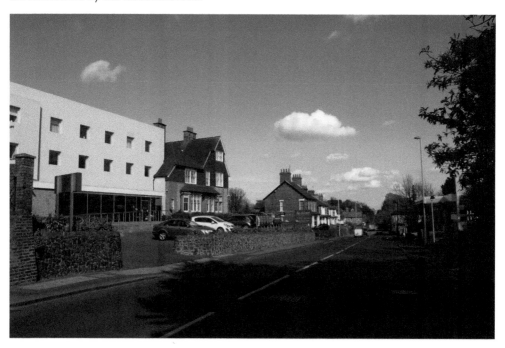

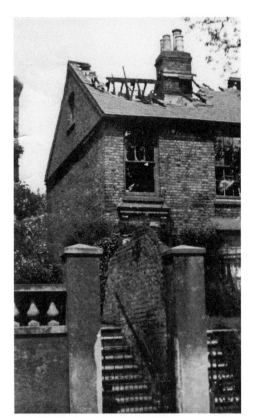

Hollybank Hill

Hollybank Hill was comprised of large houses designed for the expanding Victorian petty bourgeoisie of the town's growing economy and enriched professionals. Over the decades, many of these homes have proved perfect for conversion to offices and surgeries. Opposite is evidence of the horror of a German Zeppelin bombing raid afflicting the town here during the First World War.

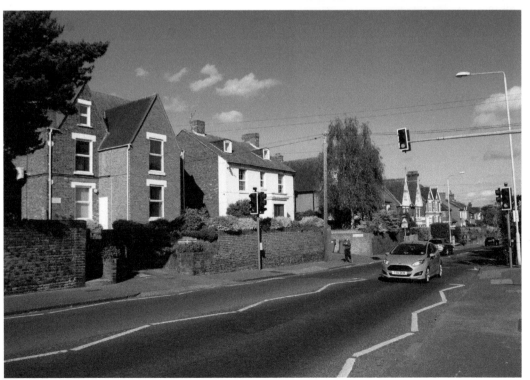

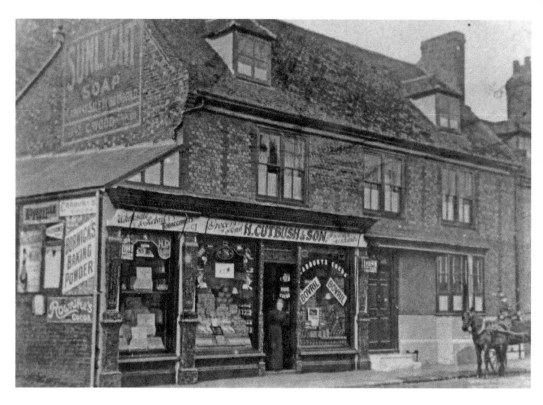

Milton Co-op

Milton Co-operative Society shop, following a recent makeover (below). It is a main hub of the High Street, with a roaring trade in lottery tickets. Unlike the Victorian outlet above, cash is dispensed from an automatic teller machine. The advertisement for Sunlight soap reminds us that this product is still available.

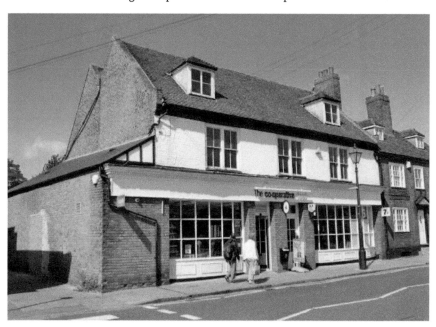

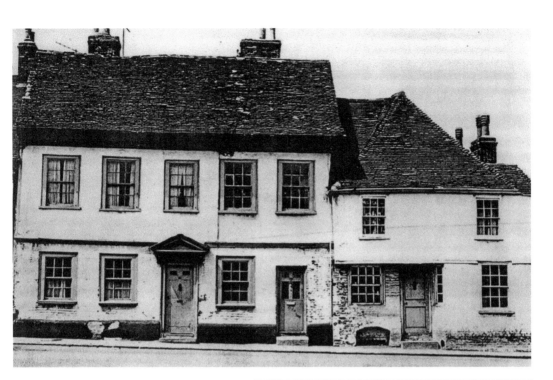

Milton High Street, North End
This area of Milton Regis High Street was where blacksmiths and wheelwrights plied their trade. The derelict building has gone and has been replaced by a car park for customers of the Charcoal Grill.

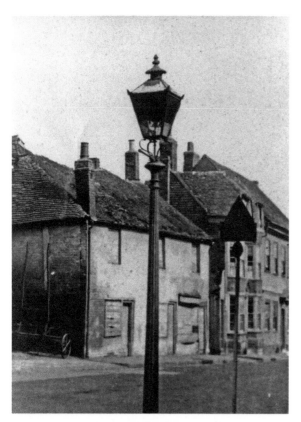

Surgeon's House, Milton
Further down the road was the early eighteenth-century residence of a surgeon. As can be seen from the before and after photographs, it has in the past been subdivided into two homes but has reverted to a single dwelling. On an ancient site, this listed building has behind its Georgian façade a timber frame of a medieval hall house. An old oak mullioned window frame survives with its original lead rings to hold lattice glass. Underneath there is a four-chamber cellar, part of which was a Norman undercroft.

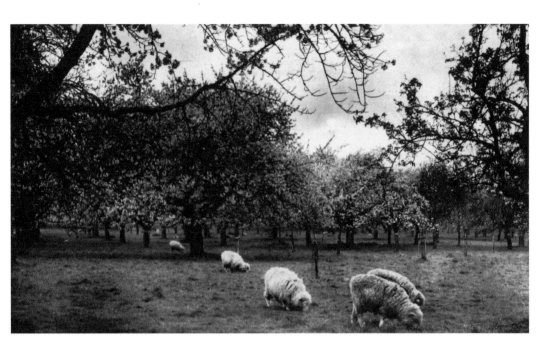

Cherry Blossom I

'The darling buds of May' is a phrase coined by Shakespeare and reprocessed by H. E. Bates, who adopted Kent as his home. In five words it encapsulates the sentimental attraction of this blessedly unique corner of England. The blooming cherry trees above were once also pastures for sheep, but lower plant conformation has precluded this. Below are the new and older plantations of expert grower Roger Francis from Rawlings Street near Milstead.

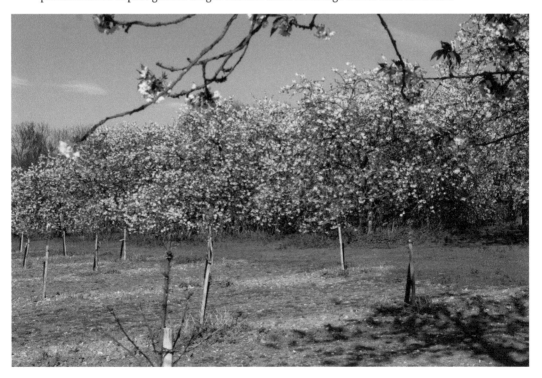

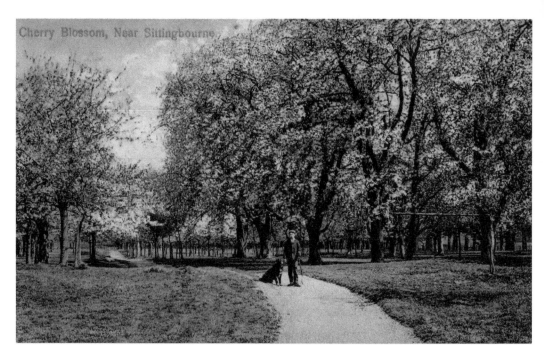

Cherry Blossom II

Old versus newer methods of fruit production are more greatly emphasised on this page. The vast standard trees above required long ladders for pickers to reach their fruit. It is more efficient and safer for row beds to be used as implemented below at G. H. Dean's perfectly managed Rodmersham Court plantation below.

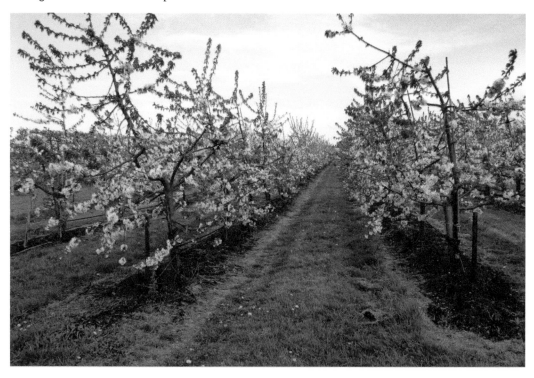

Fruiterers Arms Rodmersham

The name of Rodmersham's pub describes exactly its customers' occupations when it was established in Victorian times. Its predecessor was a fourteenth-century beer house of cruck roof construction hidden in a fold of the landscape at the opposite end of the village green. Like most present country hostelries, gastronomic fare is equally as important revenue-wise as liquid offerings.

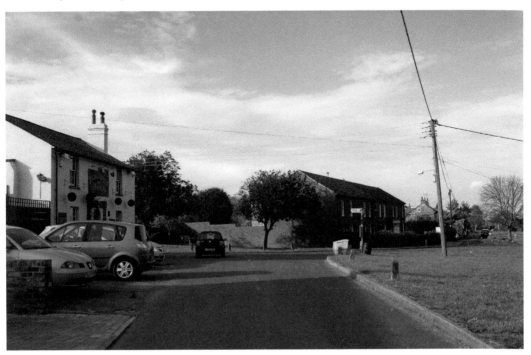

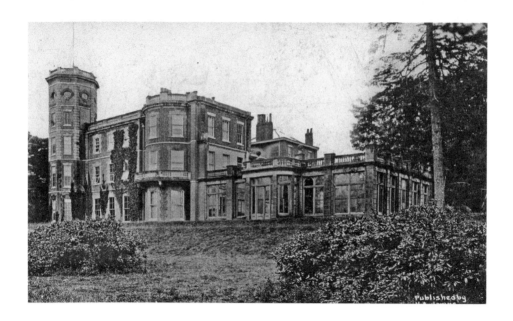

Torry Hill

Torry Hill estate at Frinsted near Sittingbourne was put together in Victorian times by the Leigh-Pemberton family. Much of the acreage is covered by sweet-chestnut coppices, which provide the raw material for traditional spile fencing. The property is exceptional in boasting not only its own small-scale steam railway (complete with viaduct – made from miniature bricks – and tunnels through woodland) but also has its own cricket pitch and fives court. A delightful, immaculate garden has been created in a redundant walled tree nursery. During the 1950s the replacement house (below), of more manageable proportions, was erected.

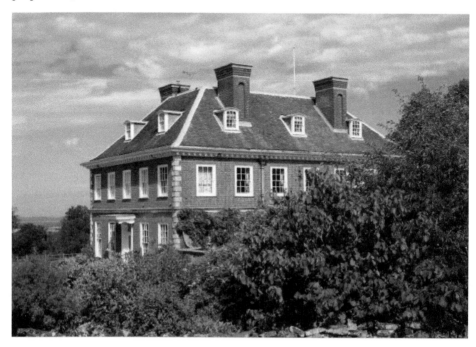

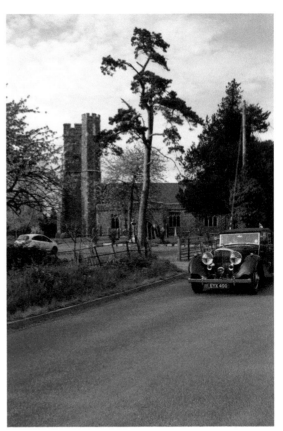

Rodmersham Church

Rodmersham church was known as the cathedral in the orchards during Victorian times. Its choir's melliferous tones were so renowned that it attracted people from Sittingbourne. Apparently they walked from there because this experience made their effort was so worthwhile. Opposite a postvintage Bentley was fortuitously captured by camera gliding effortlessly by on a quiet late spring day in April 2015.

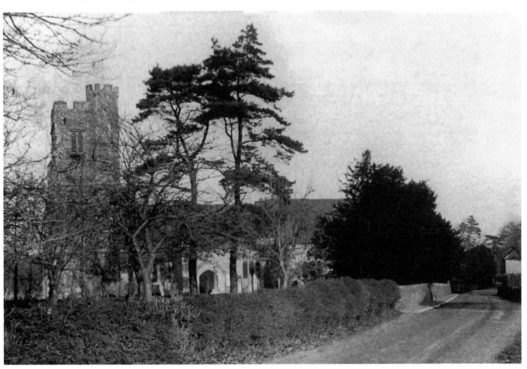

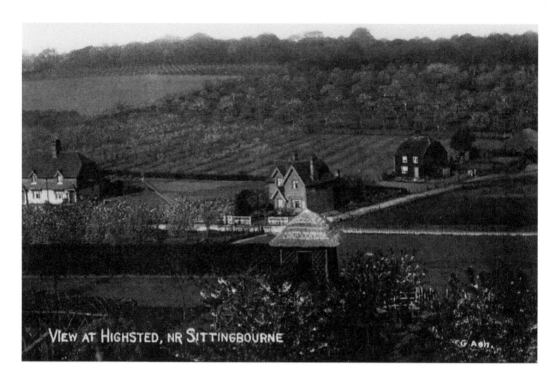

VIEW AT HIGHSTED, NR SITTINGBOURNE

G Ash.

Highstead Valley

The picture postcard above of Highstead Valley when it merely contained a farm was taken by well respected photographer Mr Ash. He ran a stationers in Sittingbourne High Street and like his competitor (Shrubsall, described earlier in of this book) is owed a posthumous great debt by subsequent topographical practitioners. The road transcribing the valley is now entirely lined by ribbon development on its western side.

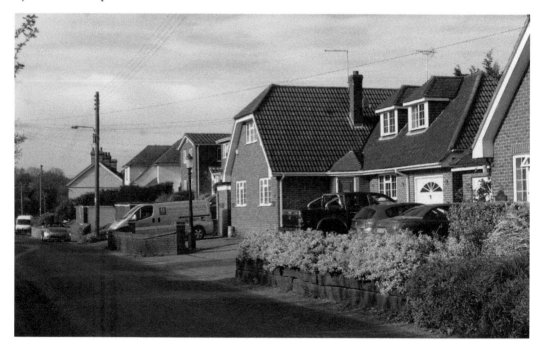

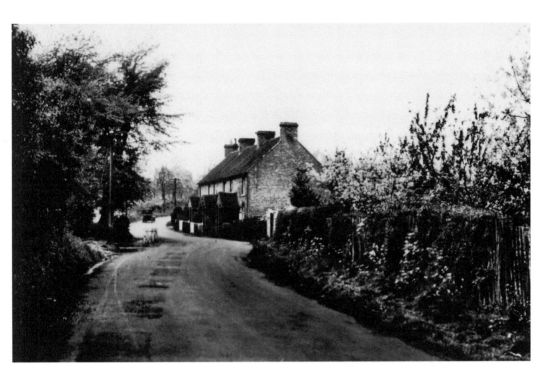

Tunstall

The small village of Tunstall is continuous to its neighbour Sittingbourne. When the lane above was photographed, the only houses there were these artisan ones belonging to the adjoining Gore Court estate. A builder's hoarding in the 'after' shot below marks the entrance to a new enlarged primary school which upon completion will serve this almost entirely urban district. This includes the opposite ribbon development which partly arose before Town and Country Planning Acts were introduced.

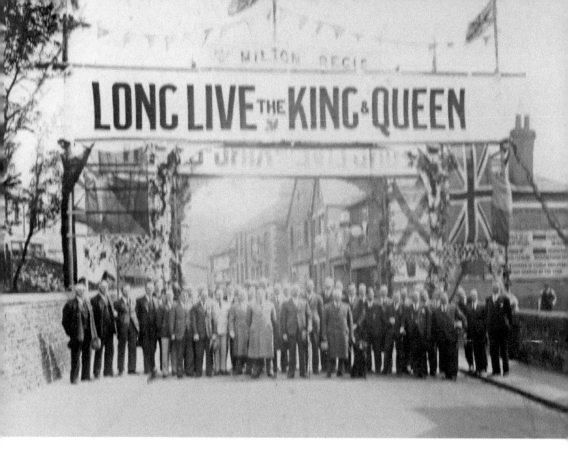

Acknowledgements

Thanks go to Mariann De Langer for her driving skills and patience. John Crunden for his unrivalled local knowledge and kind advice plus invaluable map is much appreciated. Neighbour and good friend Trac Fordyce for her indispensable computer wizardry and good humour receives a special commendation. My beloved Jocelyn Watson who without her companionship and encouragement there would be little incentive I offer my heart. Last but by no means least I should like to honour the editor of this revision Victoria Carruthers.